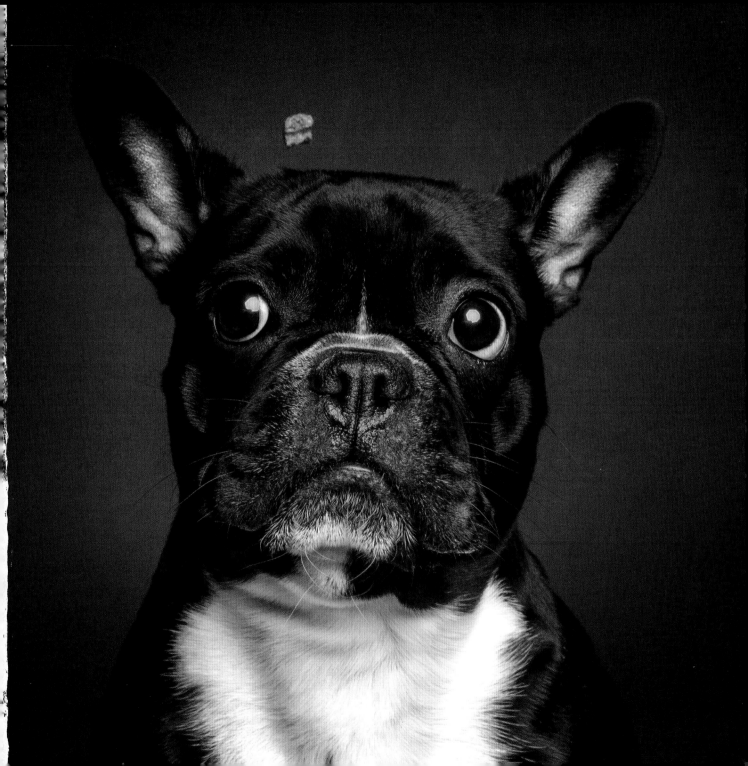

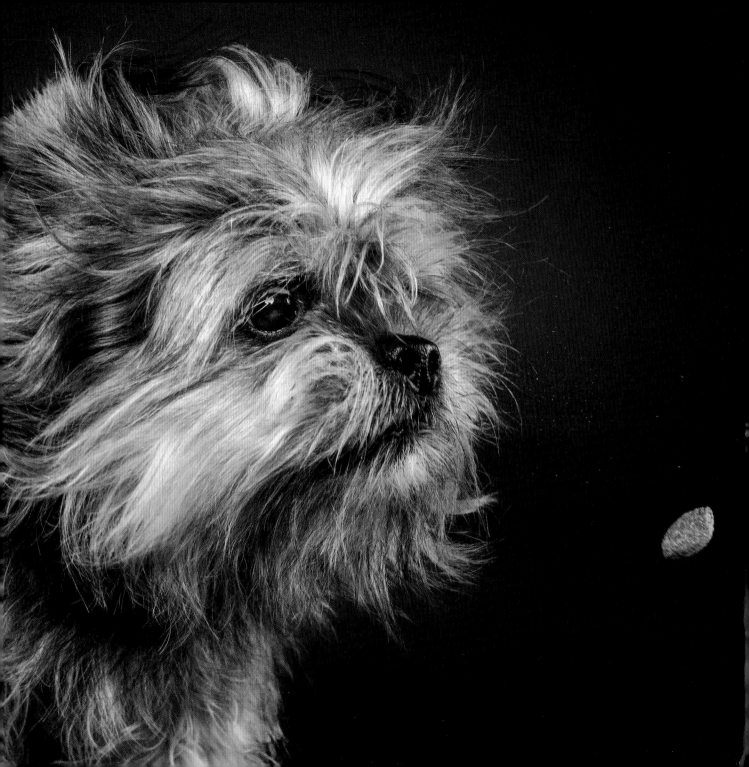

TREAT!

CHRISTIAN VIELER

BLACK DOG
& LEVENTHAL
PUBLISHERS
NEW YORK

Black Dog & Leventhal Publishers
Hachette Book Group
1290 Avenue of the Americas
New York, NY 10104

www.hachettebookgroup.com

www.blackdogandleventhal.com

First Edition: September 2017

Black Dog & Leventhal Publishers is an imprint of Hachette Books, a division of Hachette Book Group.
The Black Dog & Leventhal Publishers name and logo are trademarks of Hachette Book Group, Inc.

The publisher is not responsible for websites (or their content) that are not owned by the publisher.

The Hachette Speakers Bureau provides a wide range of authors for speaking events.
To find out more, go to www.HachetteSpeakersBureau.com or call (866) 376-6591.

Print book interior design by Elizabeth Driesbach

Library of Congress Control Number: 2016955589

ISBNs: 978-0-316-36220-7 (hardcover), 978-0-316-36222-1 (ebook)

Printed in China

APS

10 9 8 7 6 5 4 3 2 1

I DEDICATE THIS BOOK TO MY DOG LOTTE.

She'll never know that she completely changed my life.

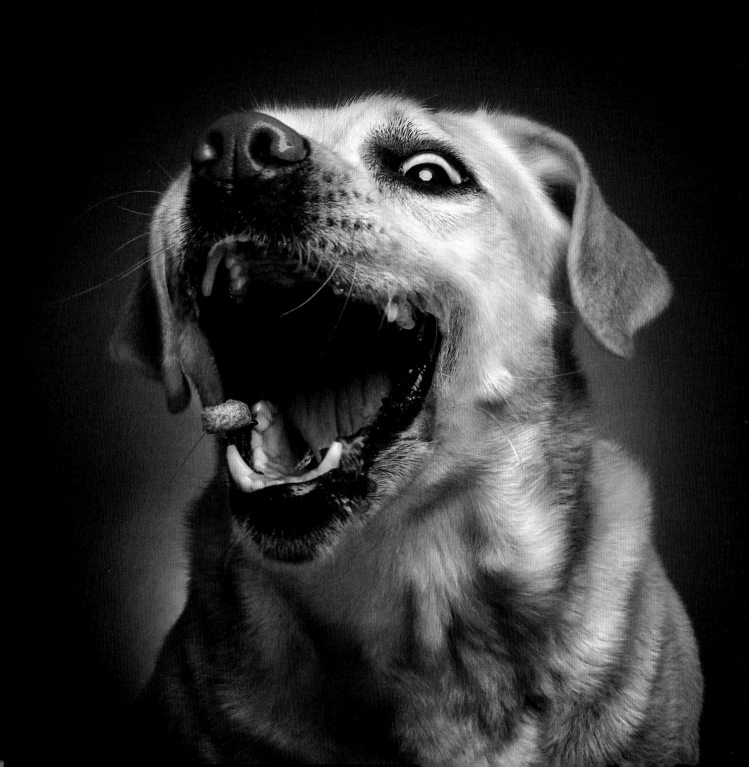

INTRODUCTION

I often hear "but . . . that dog looks ugly" when I show people my *Treat!* pictures—people who don't have dogs, that is. Then they click a little further into my portfolio and point to a classic portrait: "That's nice, I like that. Do more of these." I know what they mean. The wide-open mouth of a dog with big teeth lunging for a treat can be shocking—and sometimes scary. Plus there's often some drool flying around and the pup's cute face can get distorted.

These pictures, though, possess a particular magic all their own. At first, I didn't understand why. I stumbled upon them by accident and just thought they were funny. I had been an amateur photographer for two years, mostly photographing dogs in my studio and outdoors. I really liked the artificial effect of flash, but seldom came across electrical sockets when I was out in the woods to shoot. So I treated my-self—for a great deal of money for me at the time—to a portable flash with a battery, which allowed me to work with shutter speeds that could "freeze" movement. Normal studio flashes allow for speeds of up to a maximum 1/250 of a second, but with this new flash, I could work at up to 1/8000 of a second. I wanted to use this in my work, but I had to try it out first. That's where my beloved Labrador Lotte stepped in. She patiently submitted to every new setting I tried. In order to set the somewhat gentle dog into motion, I began to throw treats for her. If there's one thing that will always get a Labrador moving, it's the prospect of a tasty tidbit. At first I focused on the sharpness of the images, but then I gradually noticed how this approach created to all kinds of crazy pictures. I eventually photographed every dog that came into my studio this way at the end of a normal portrait shoot—a kind of reward for keeping still for so long.

After developing more than 500 snapshots, I now know these photos that some people think are ugly actually bring these dogs closer to our hearts. In that momentary shot we are able to experience our best friends as we seldom do in everyday life. We recognize their panic, joy, fear of loss, sheer desire, and the very pinnacle of enjoyment—something we normally only experience from other human beings. The dog reveals a human side while nevertheless remaining a dog. That's why *Treat!*, for me, is not simply an entertaining book with funny pictures—it heals your soul.

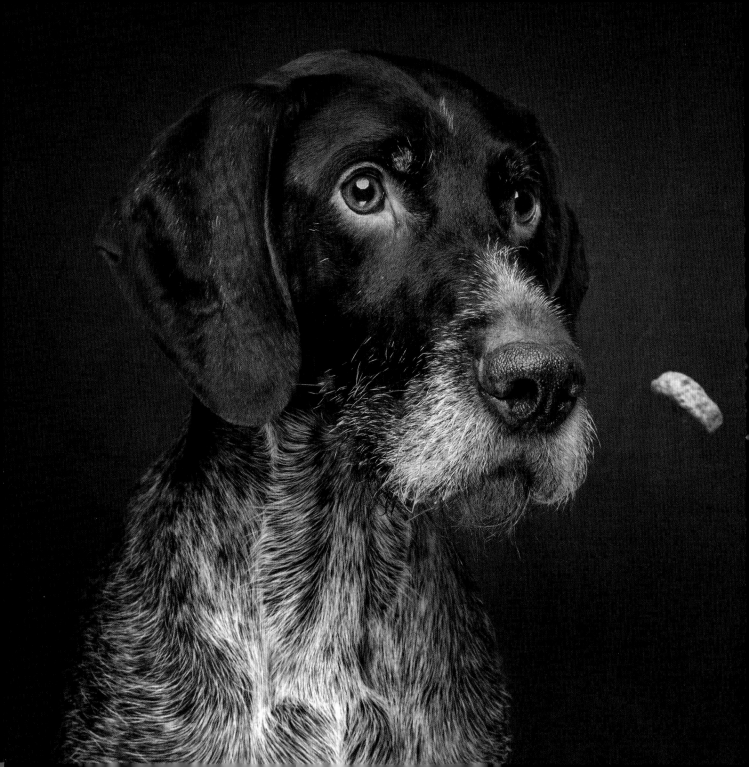

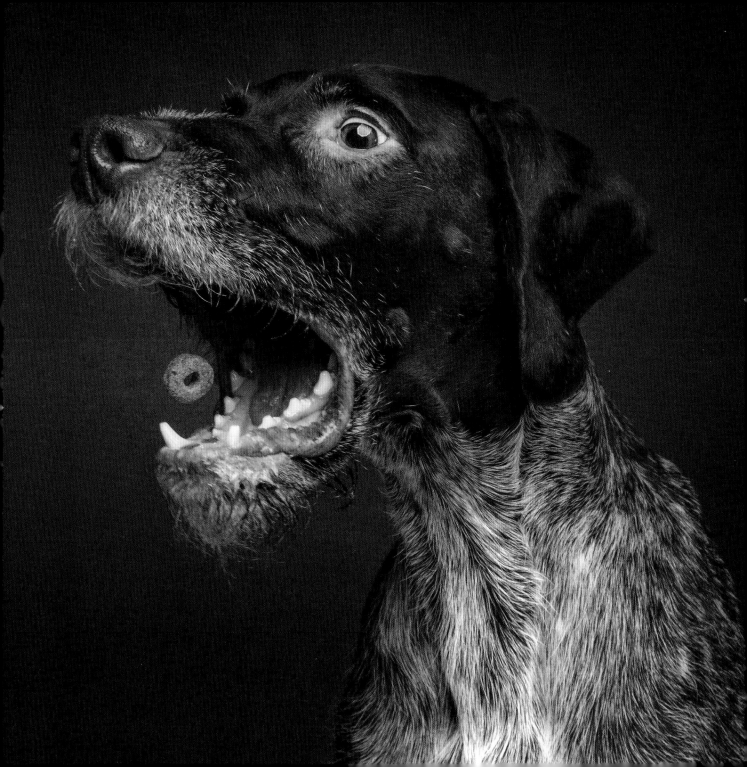

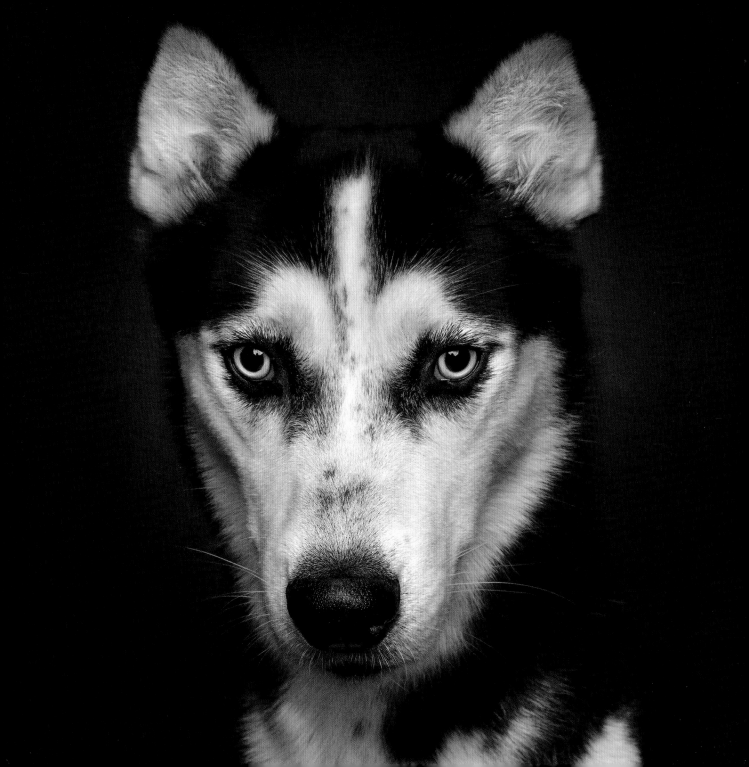

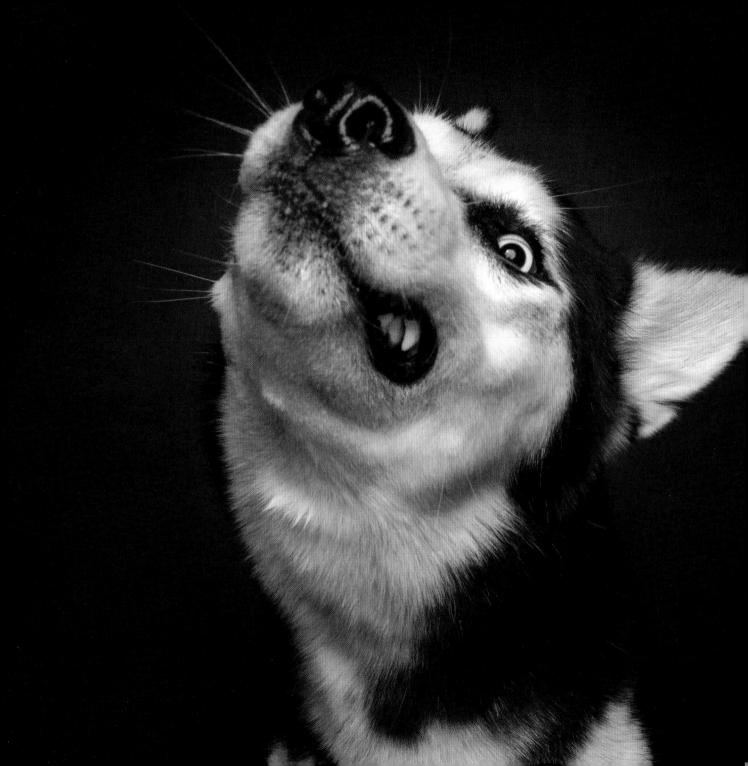

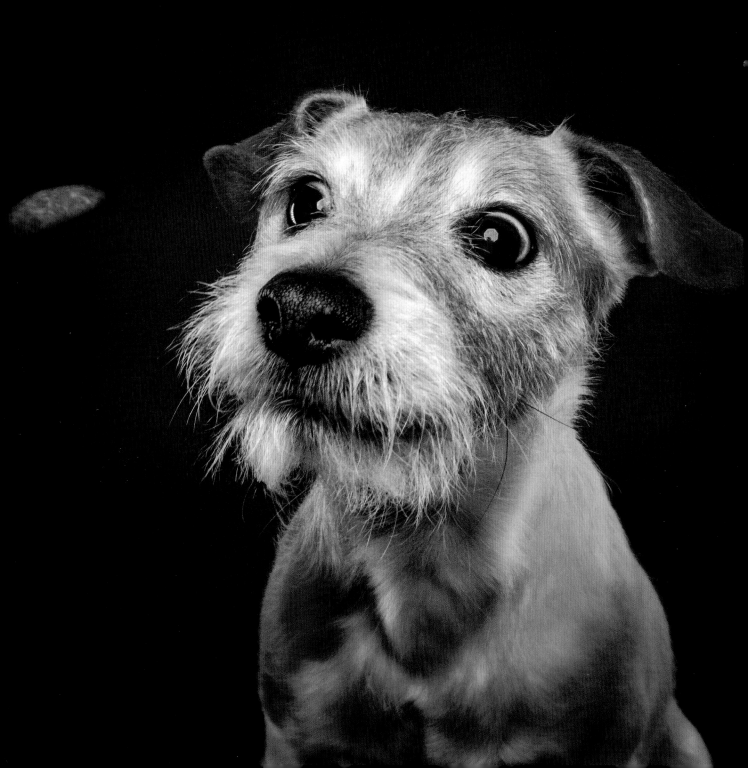

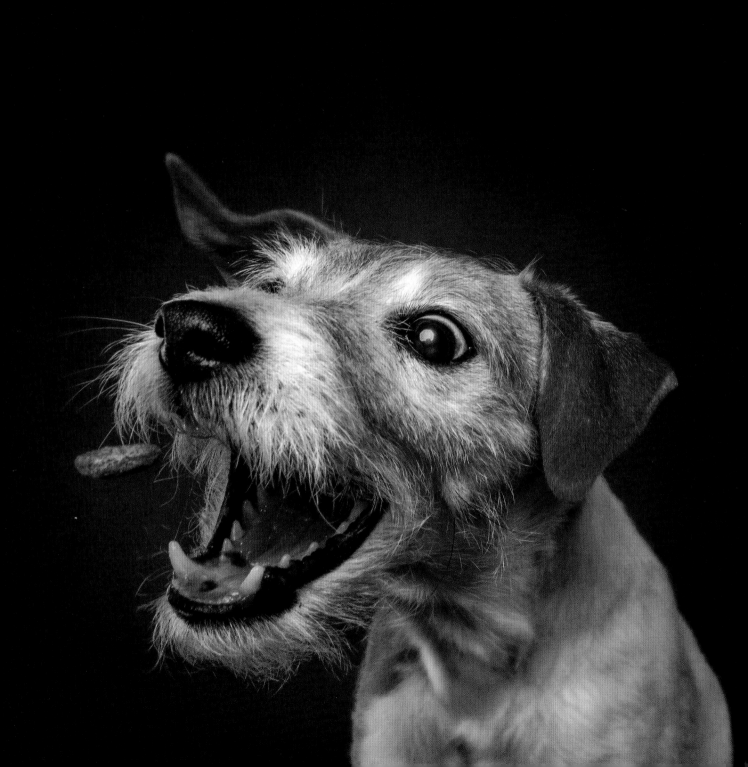

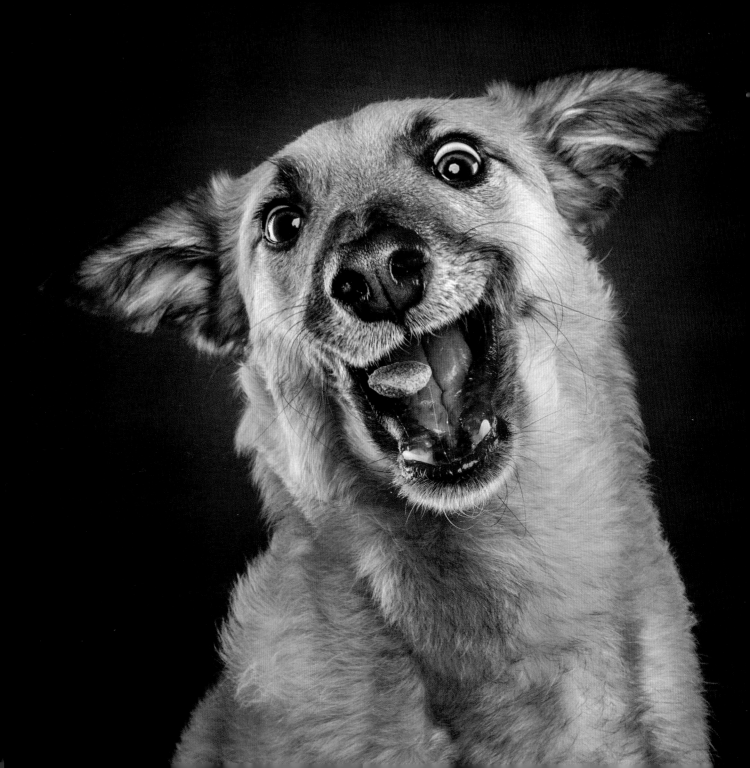

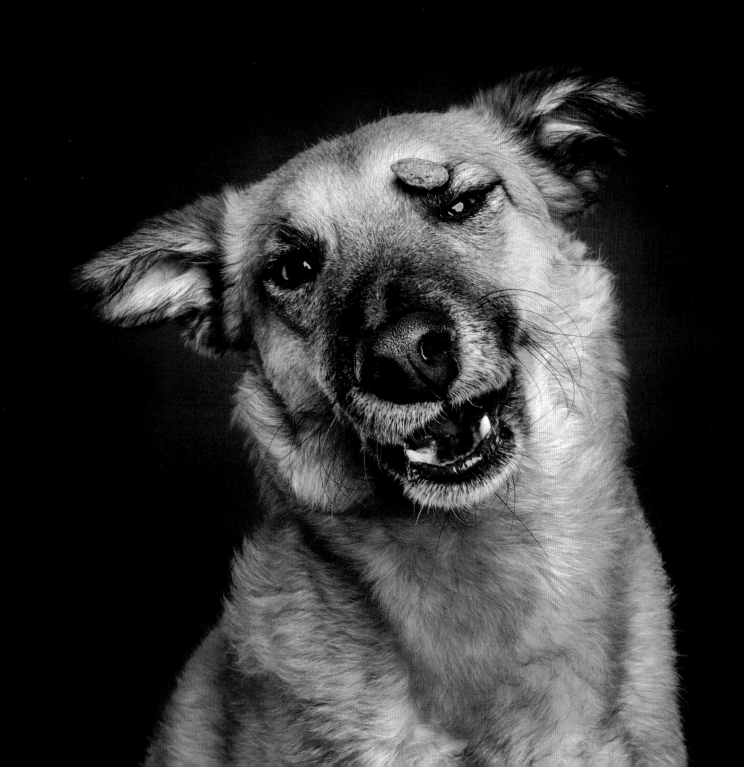

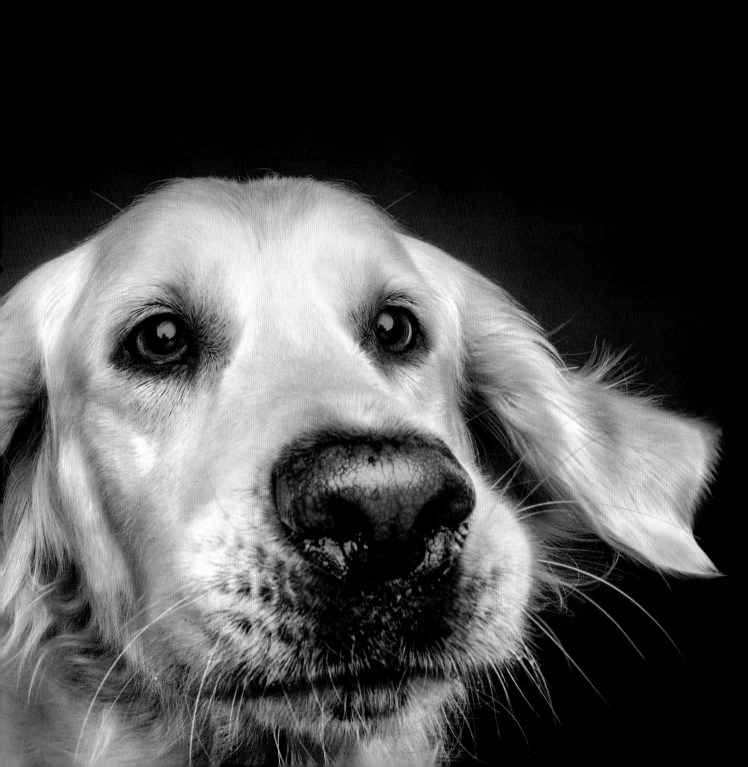

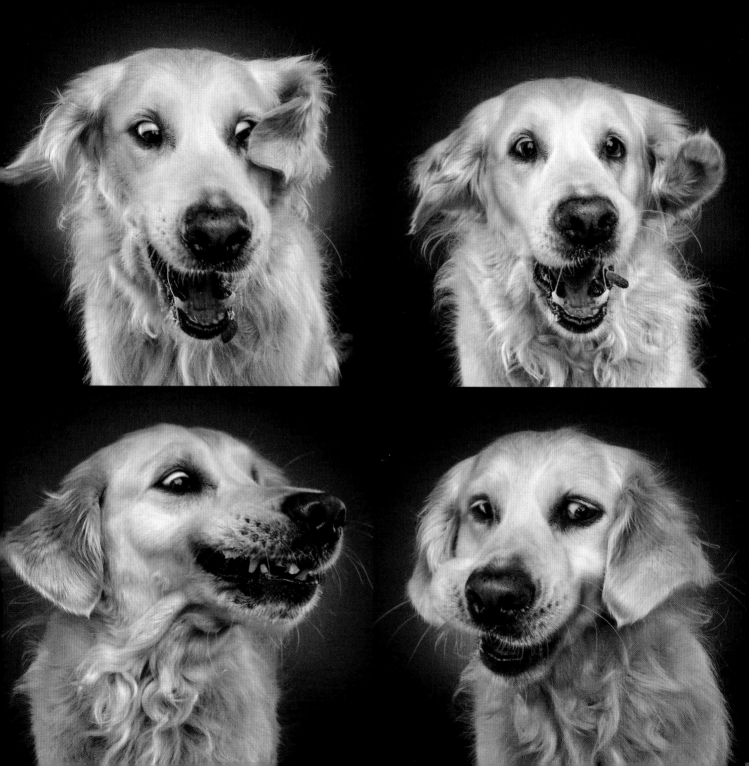

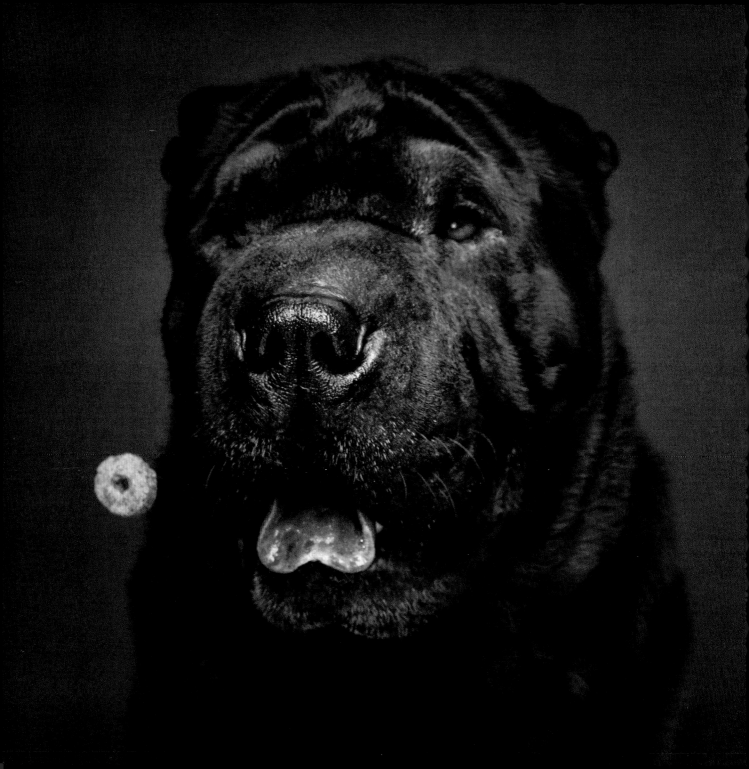

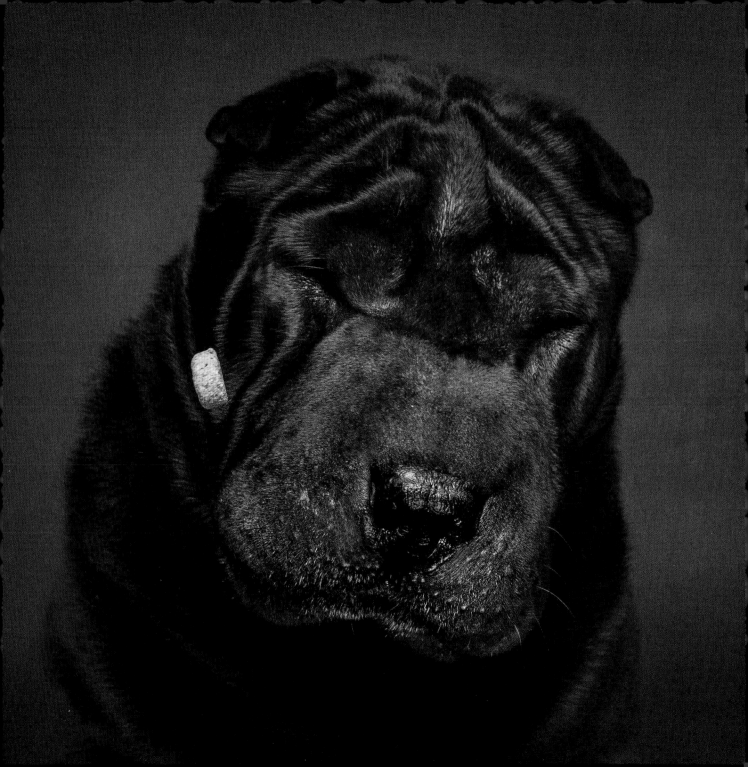

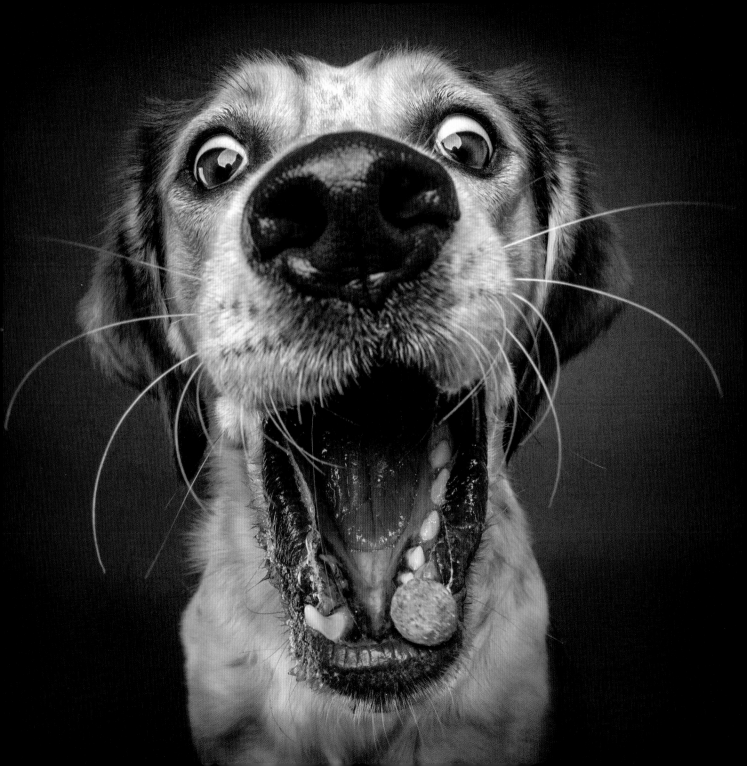

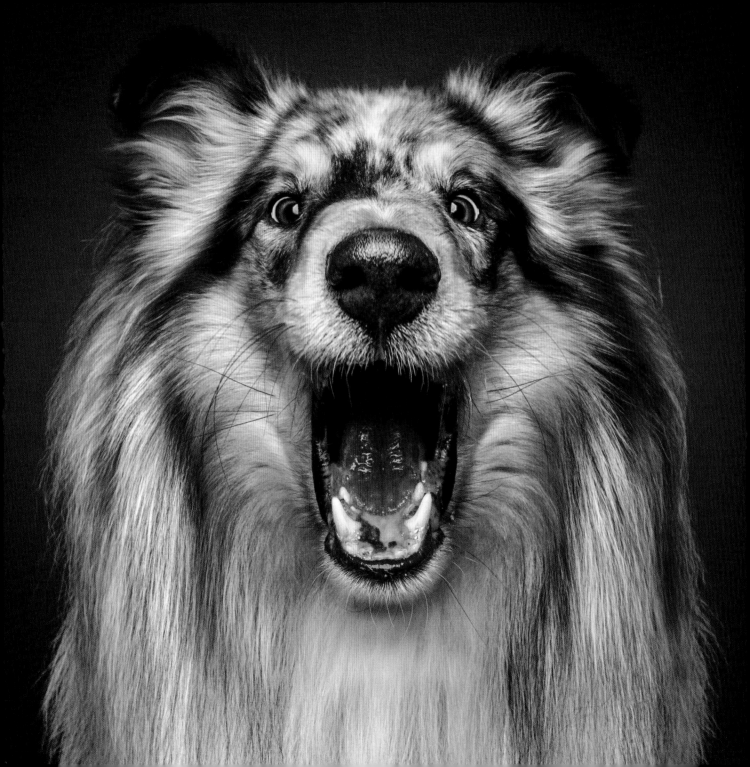

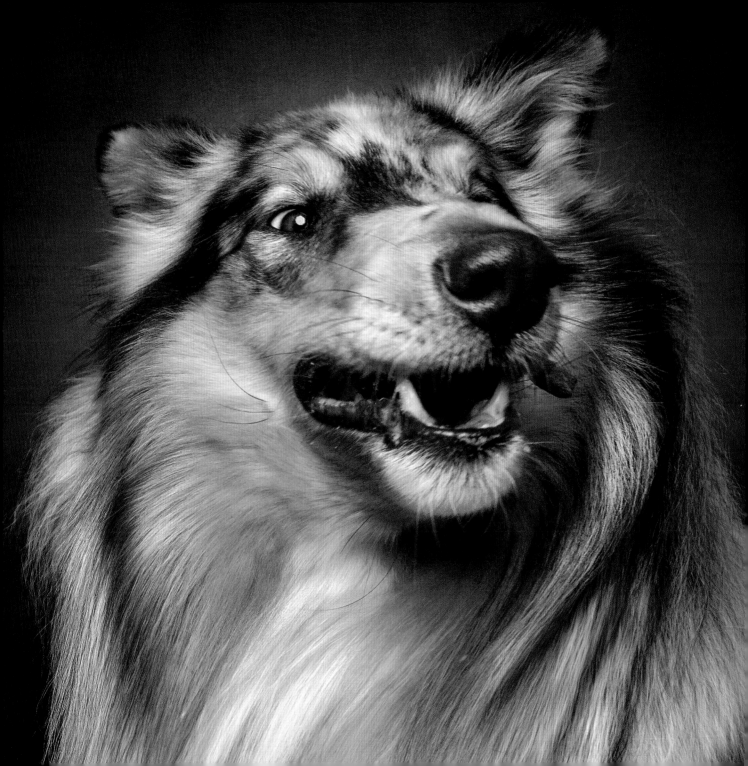

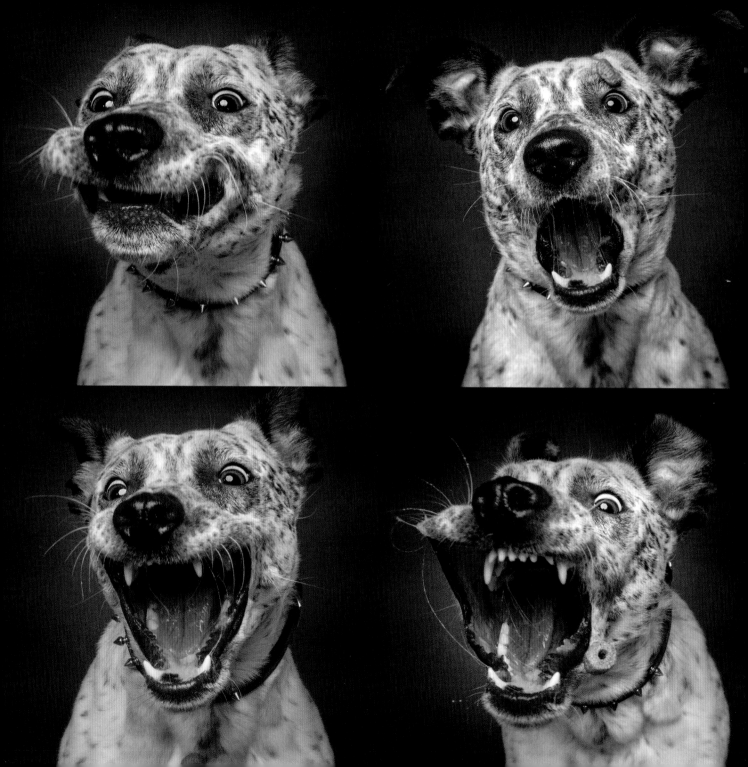

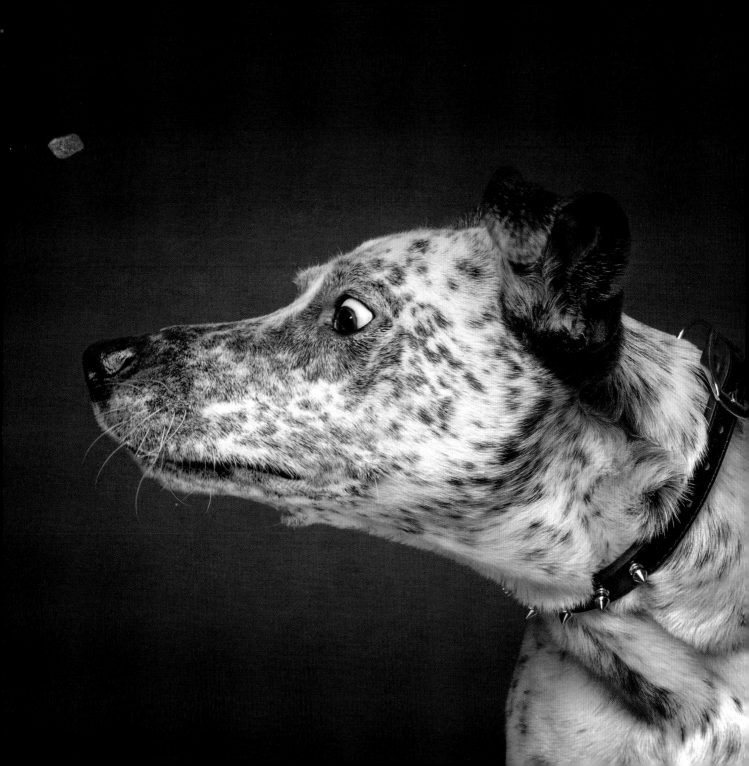

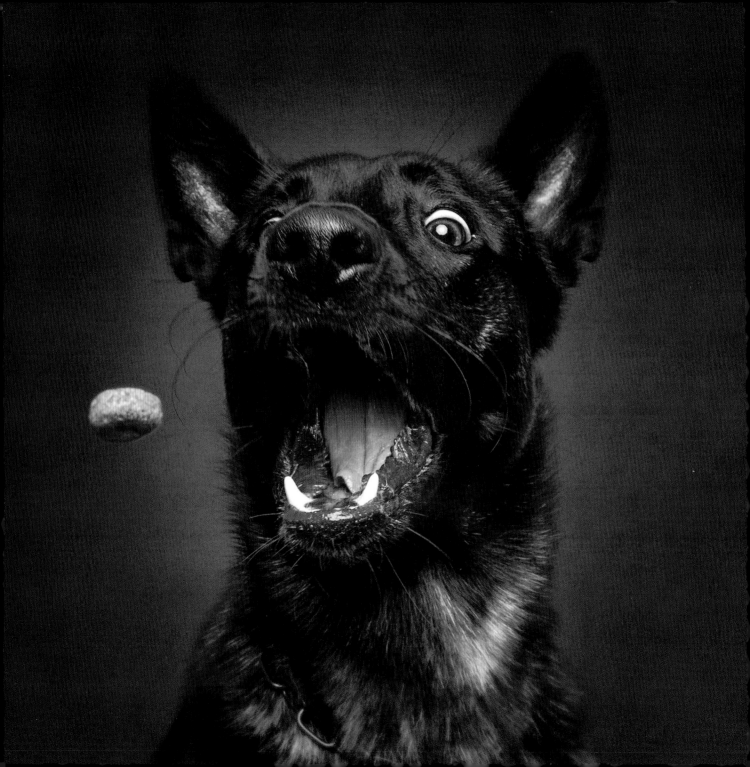

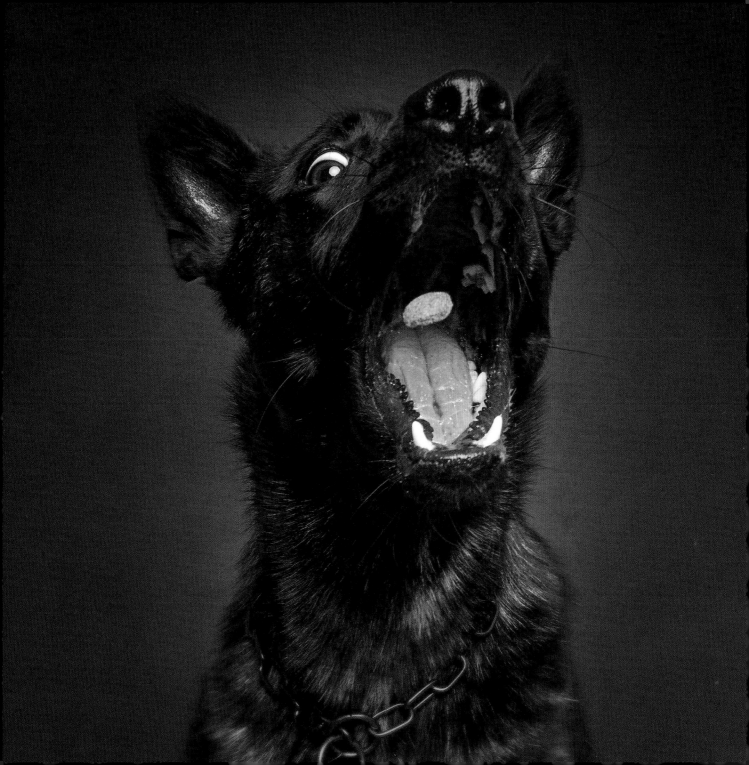

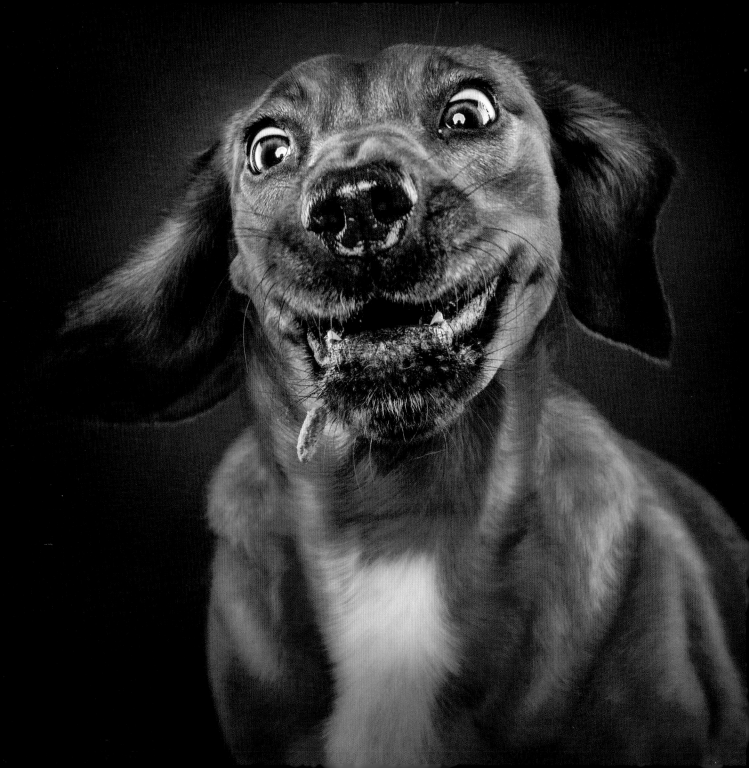

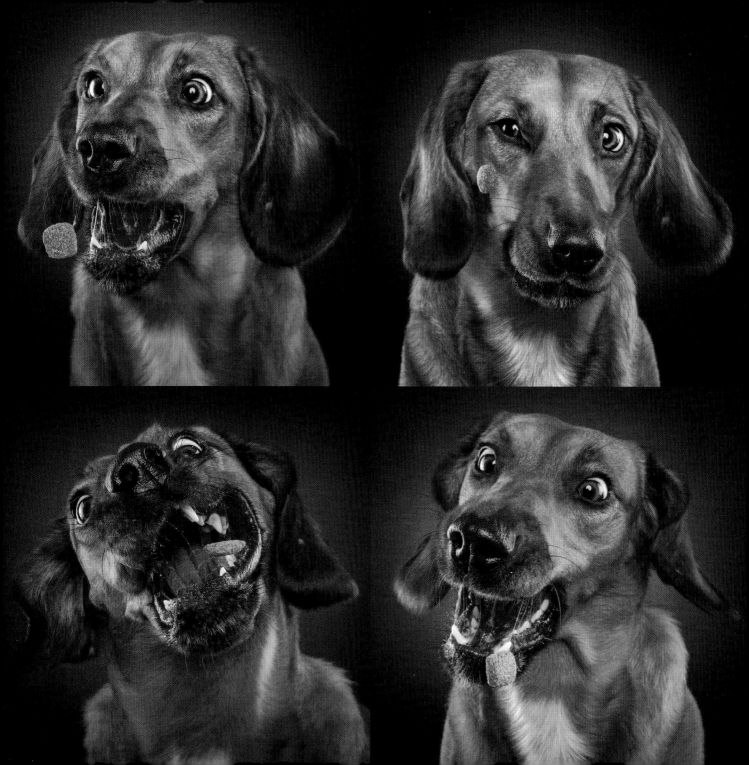

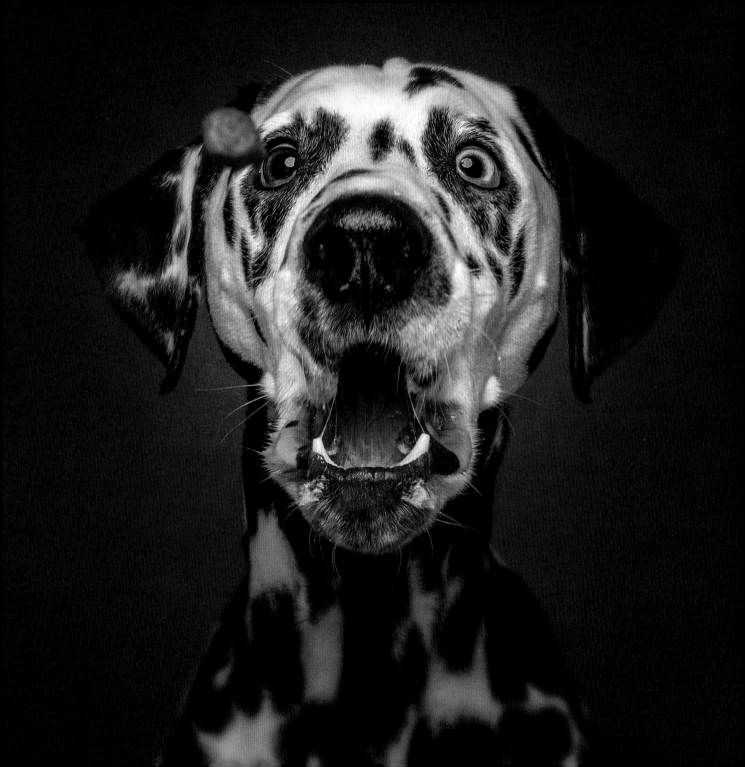

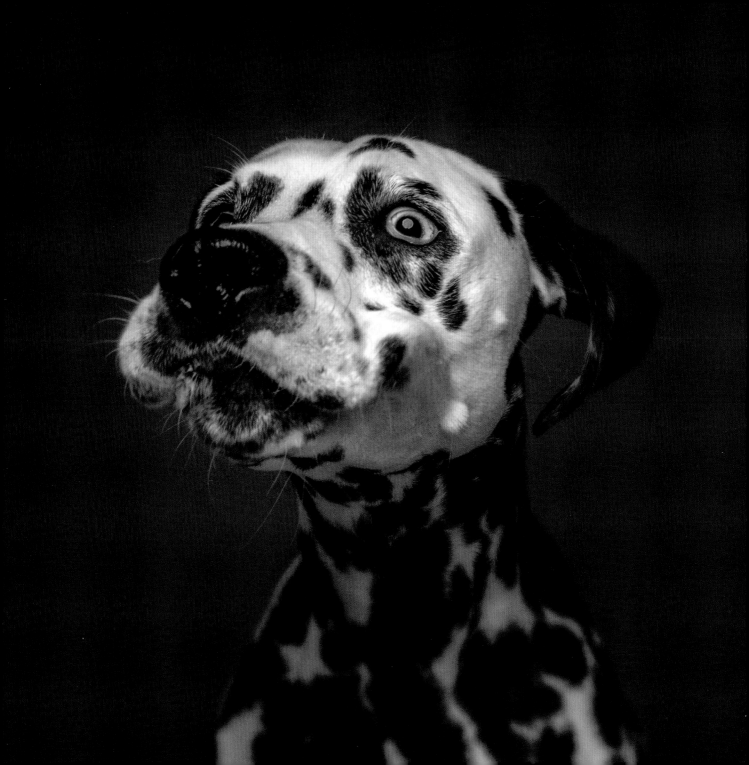

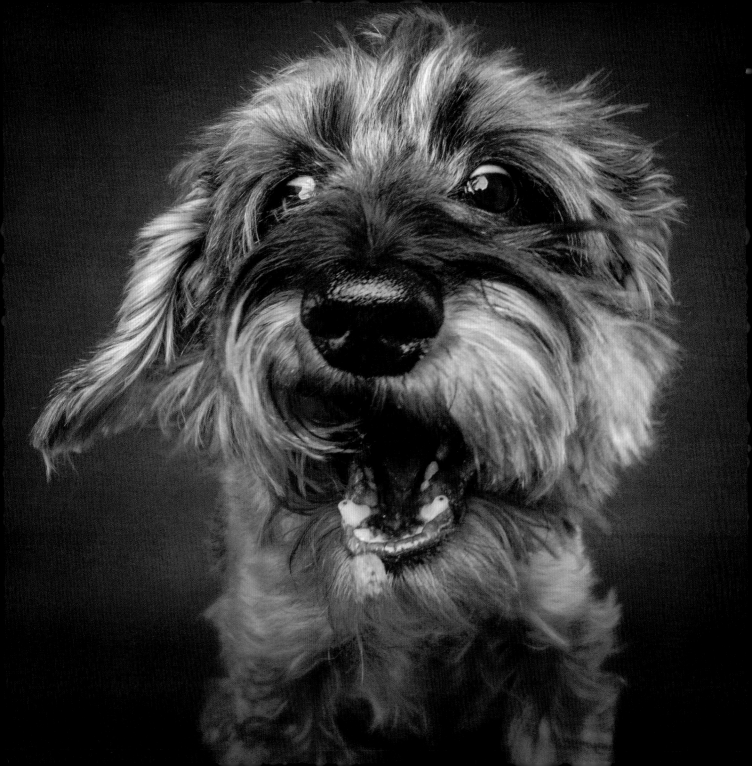

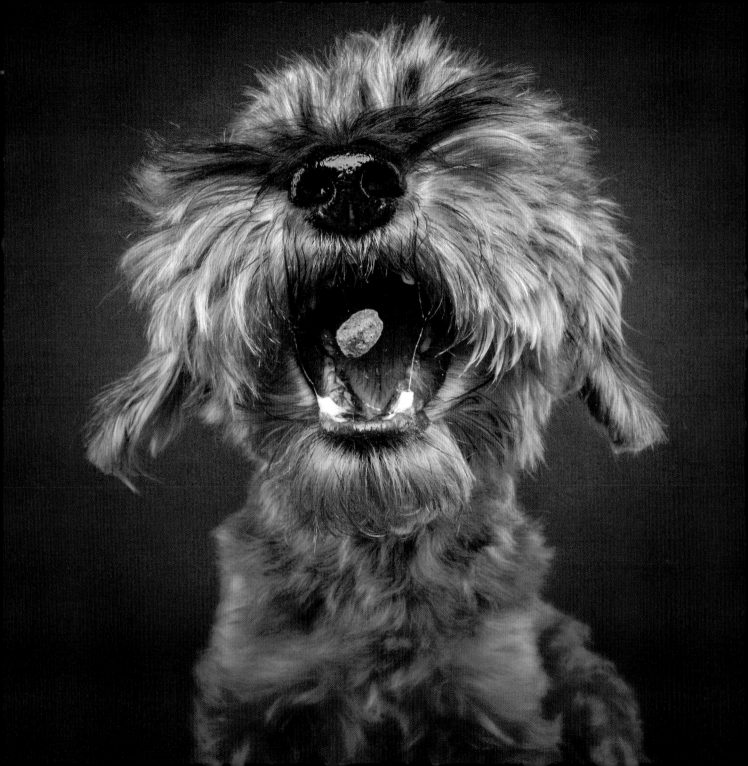

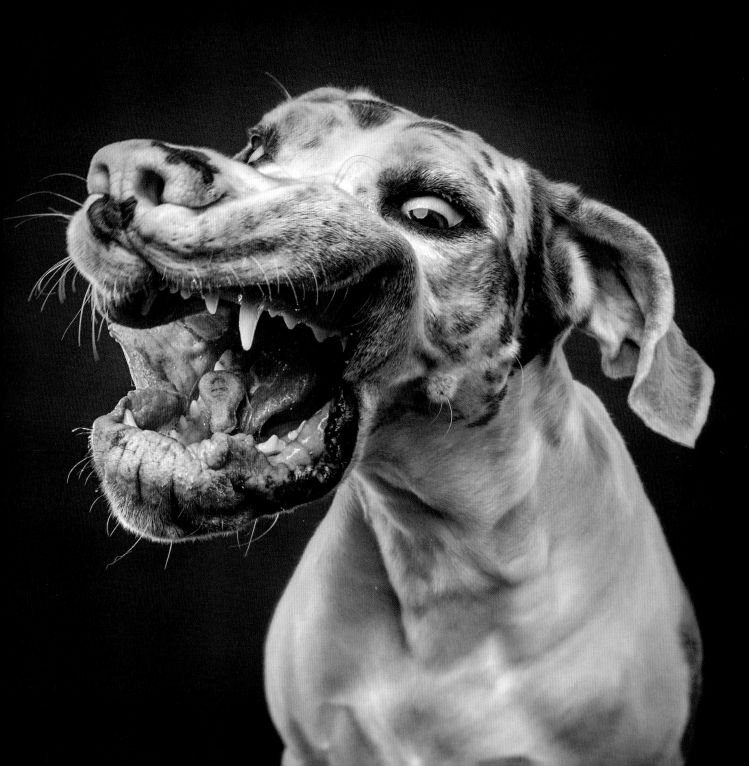

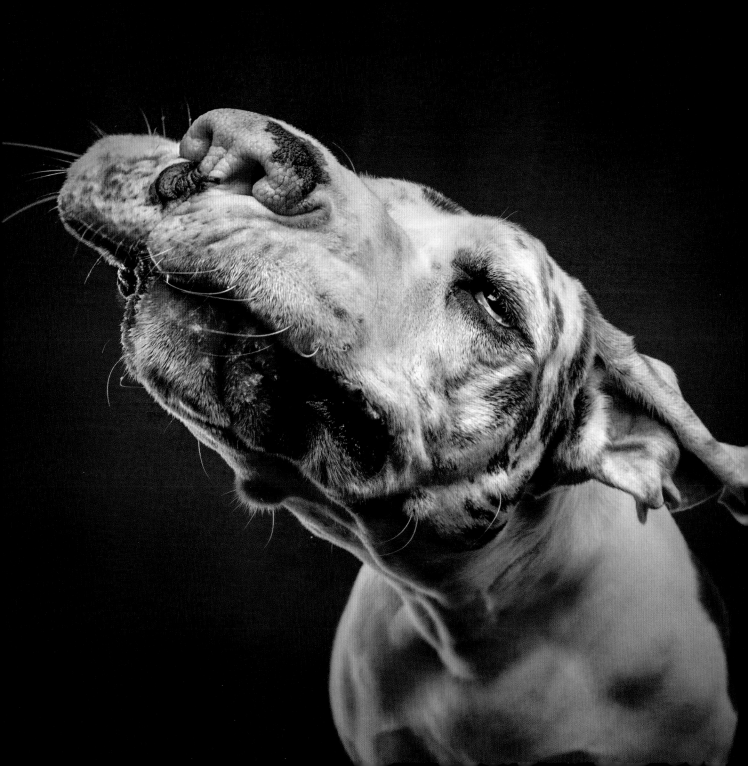

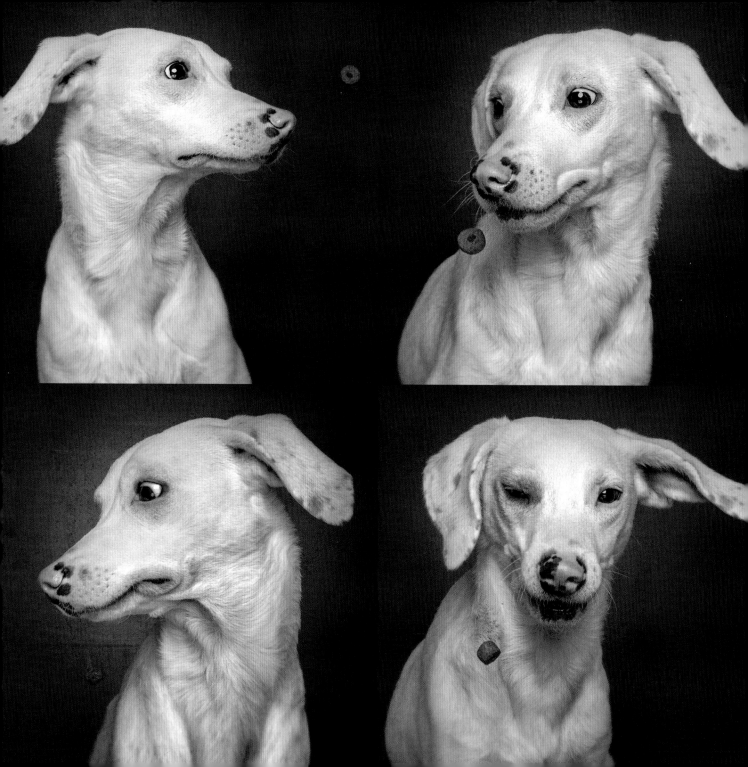

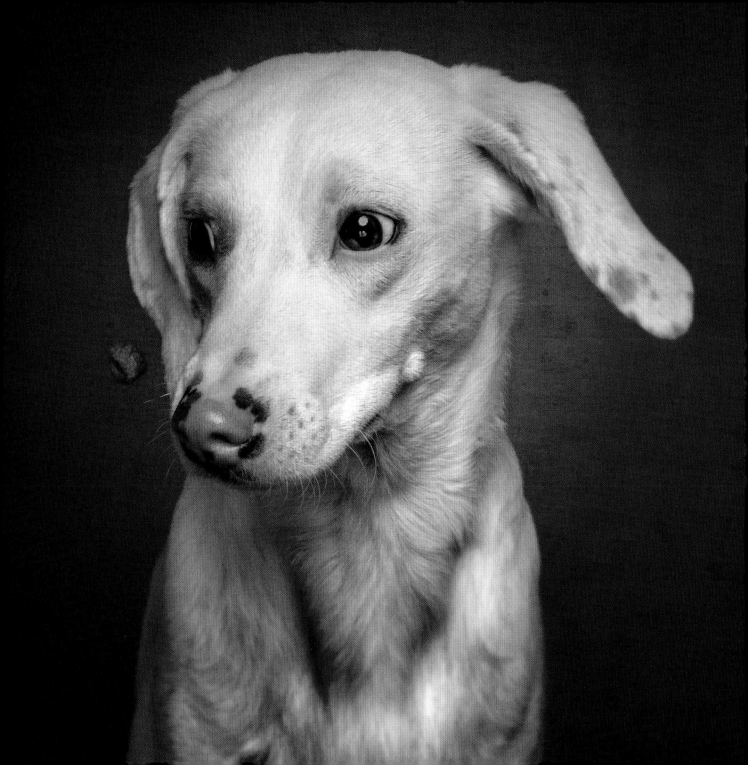

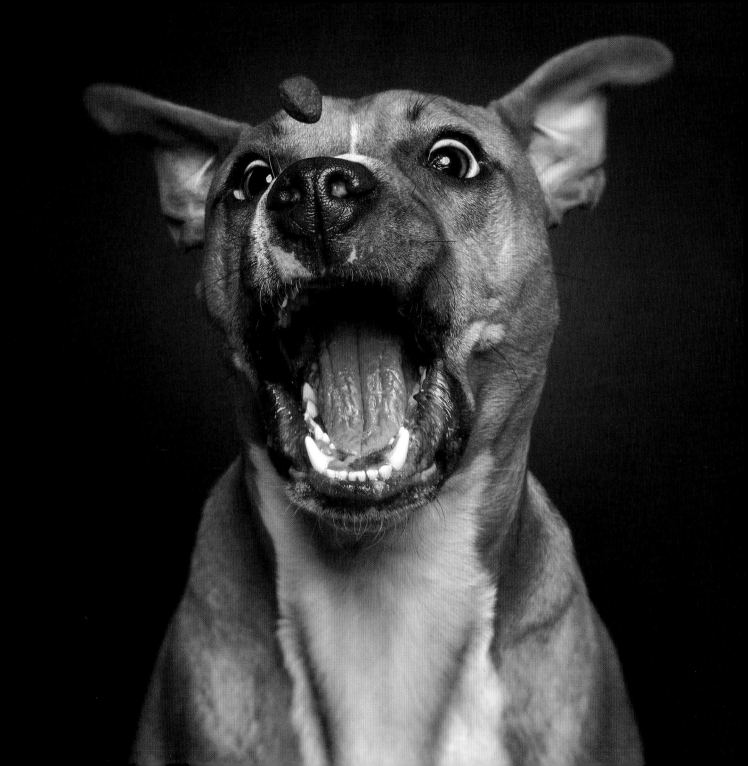

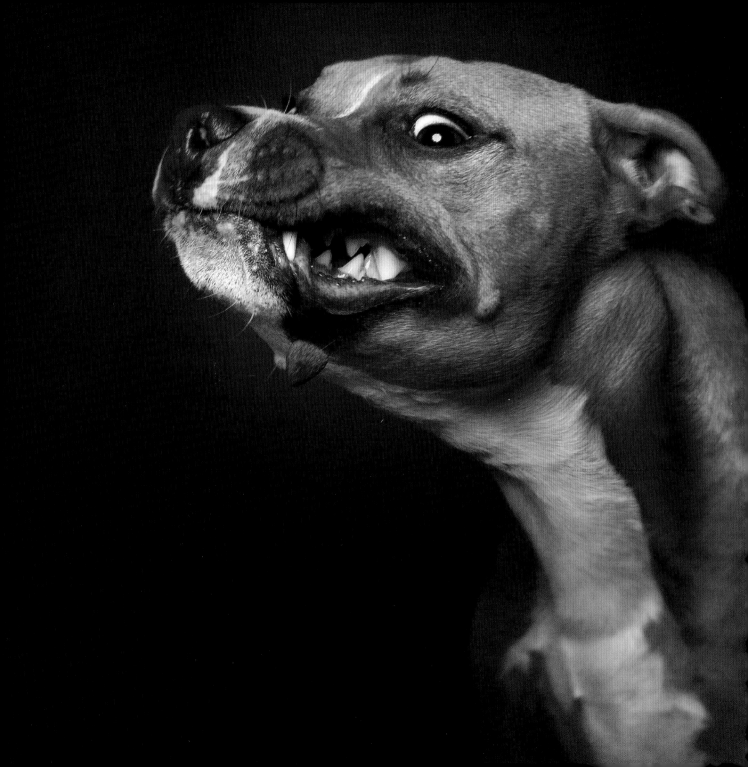

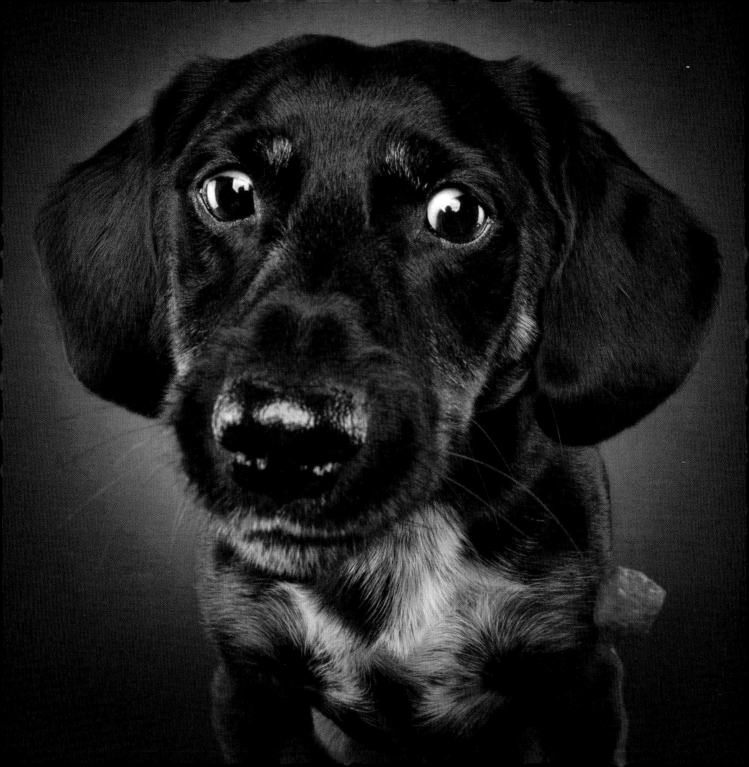

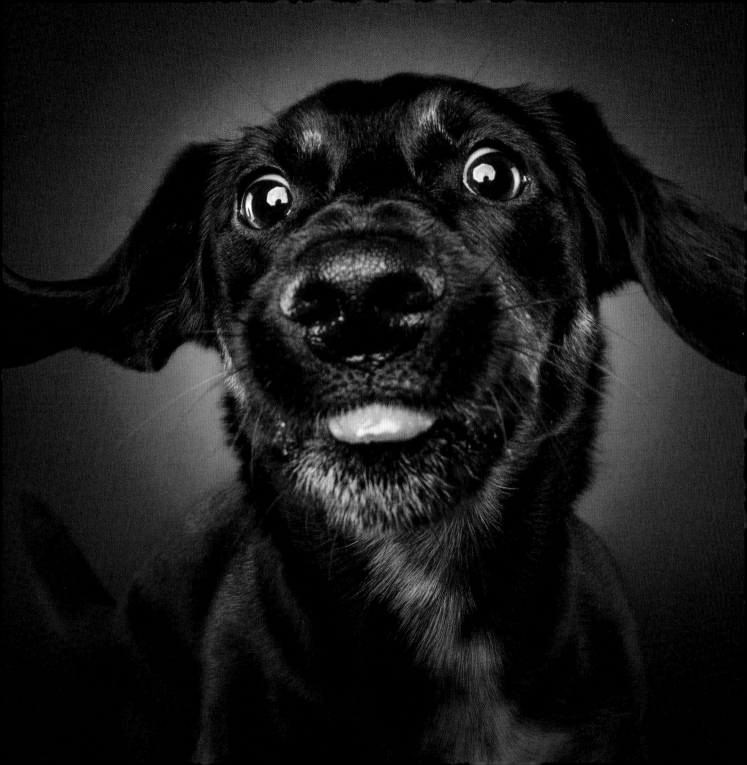

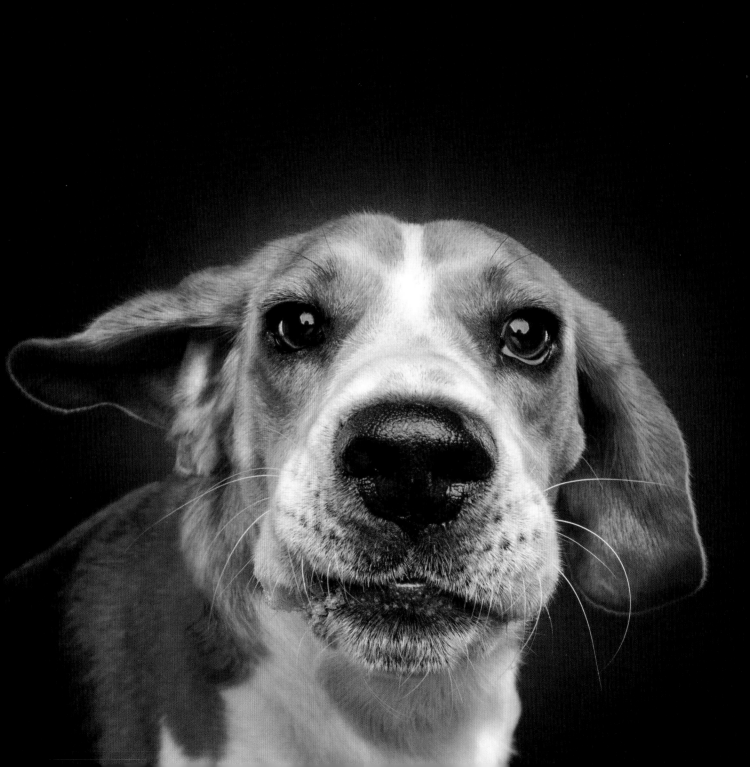

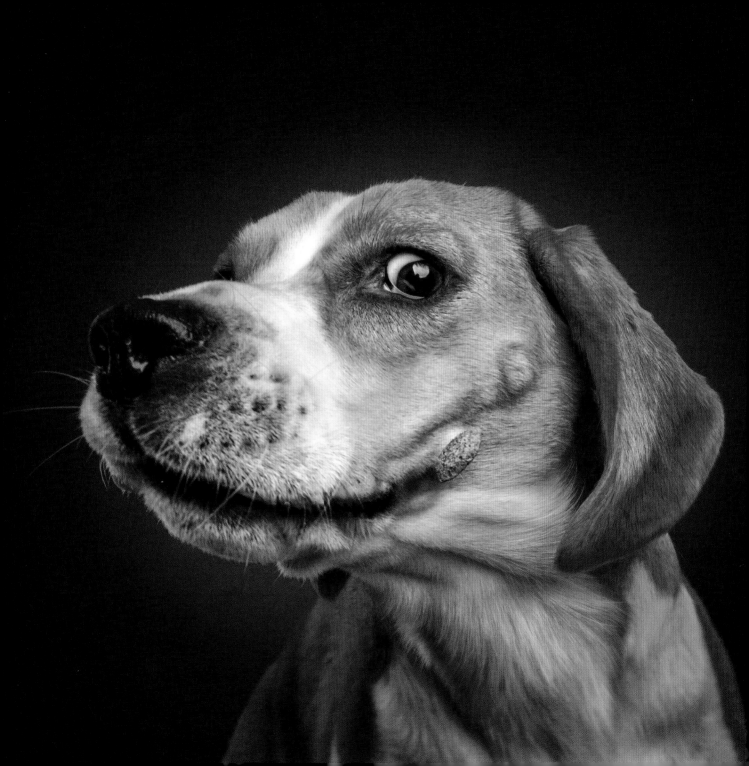

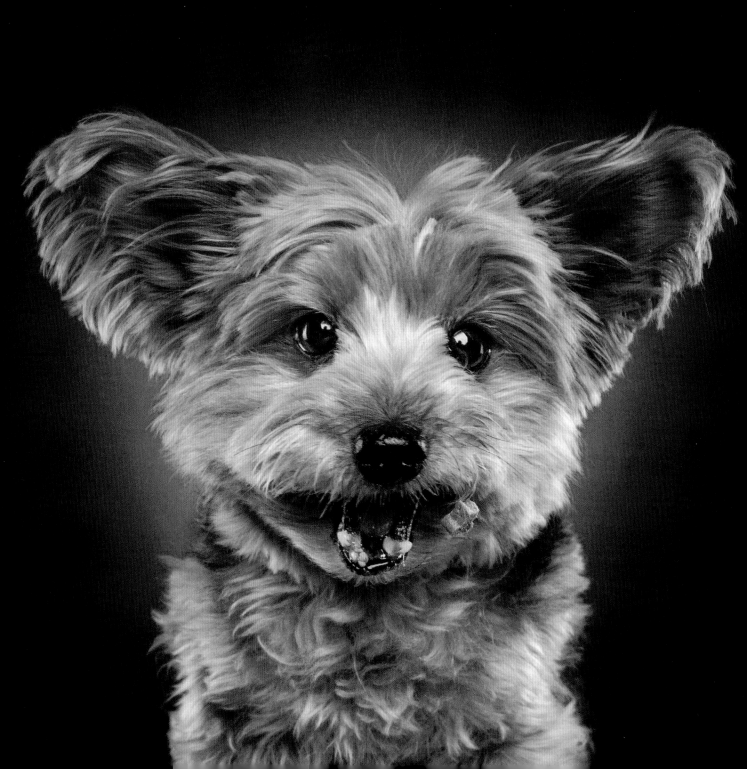

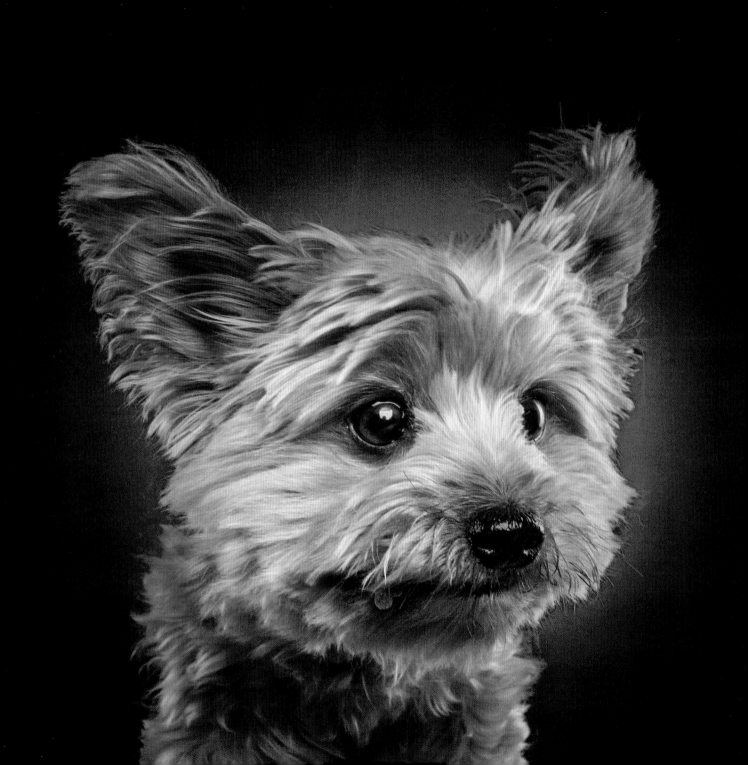

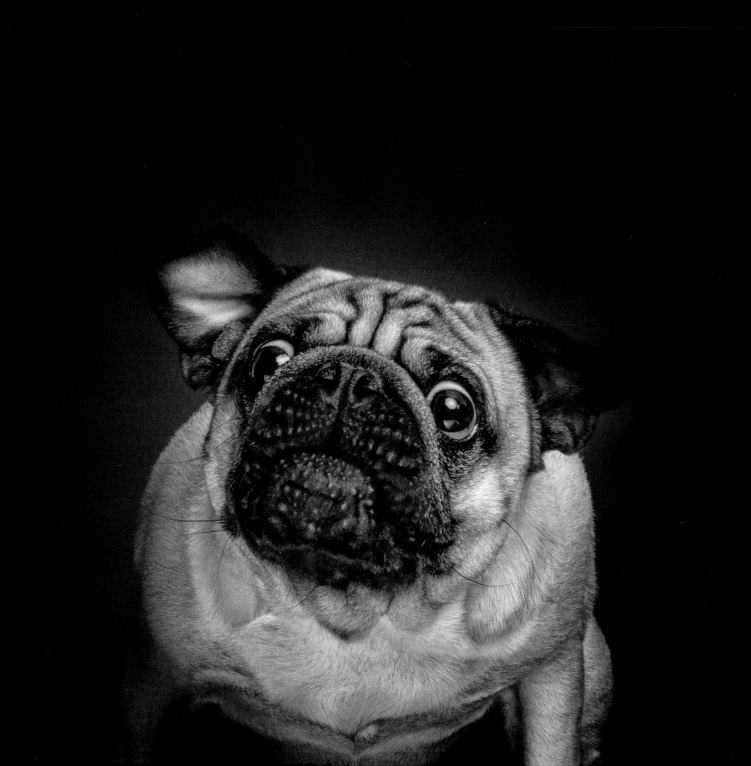

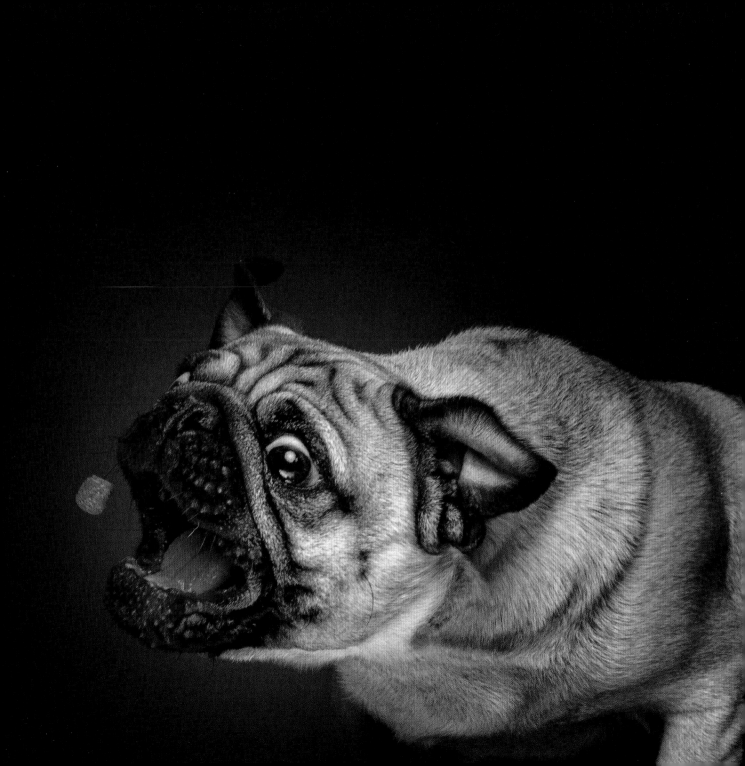

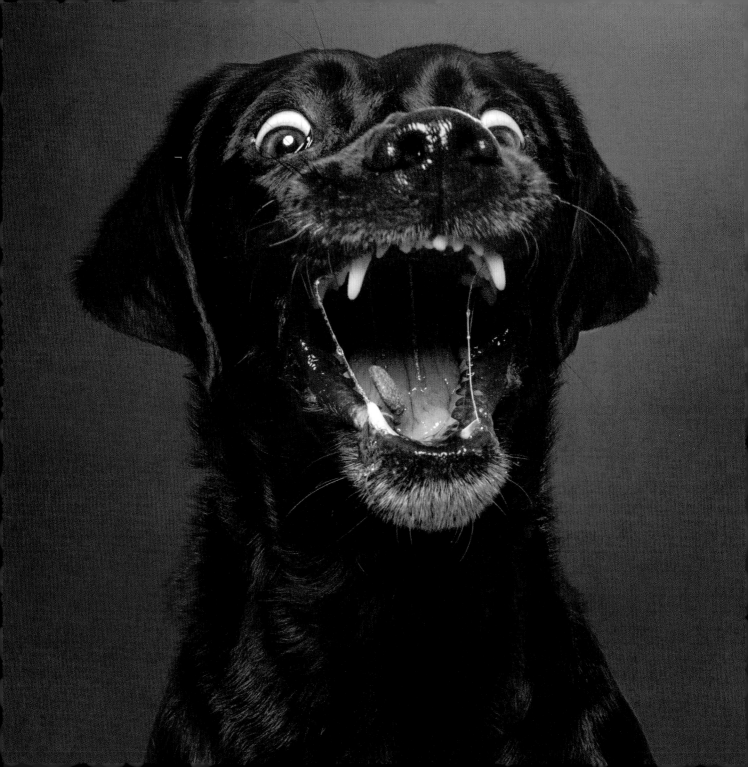

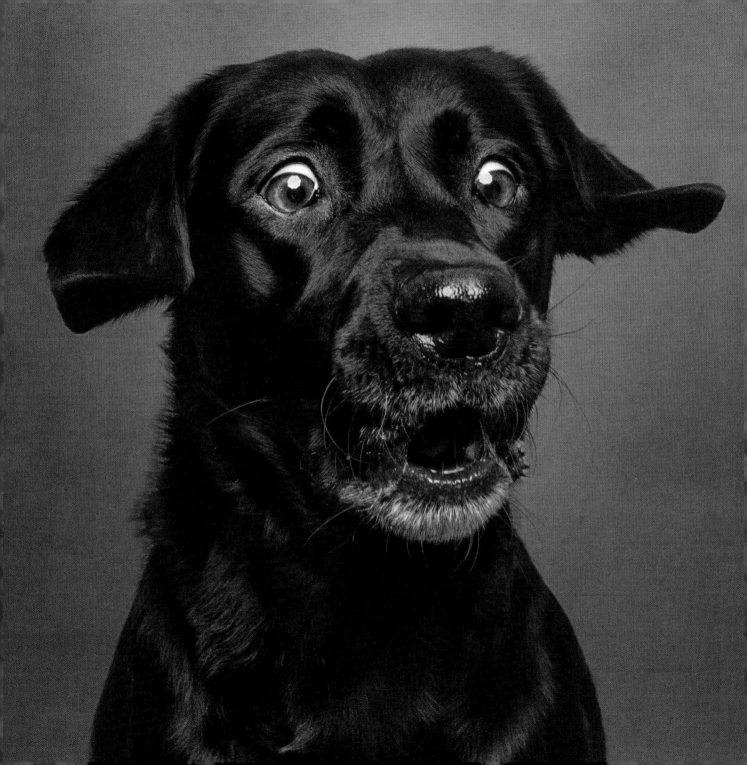

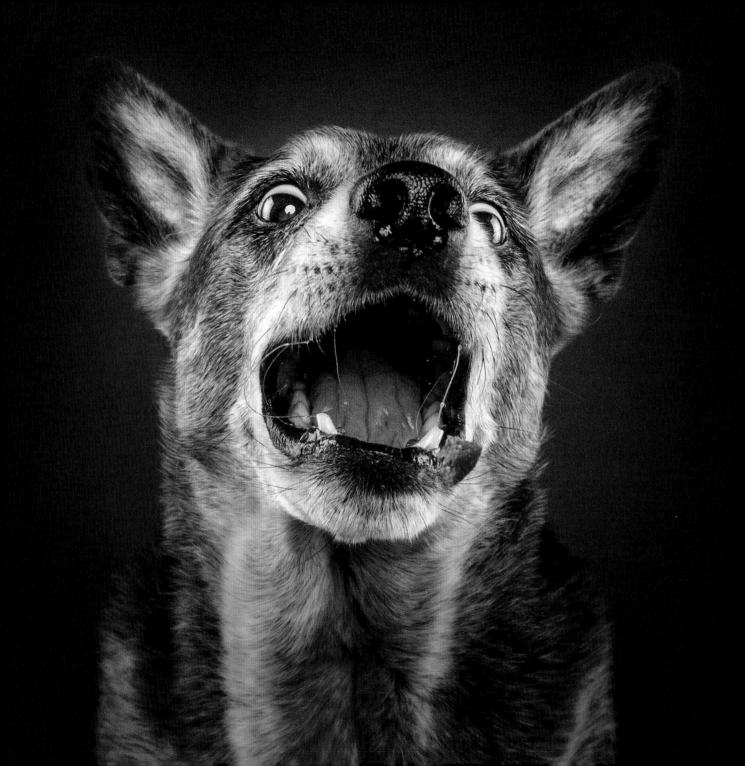

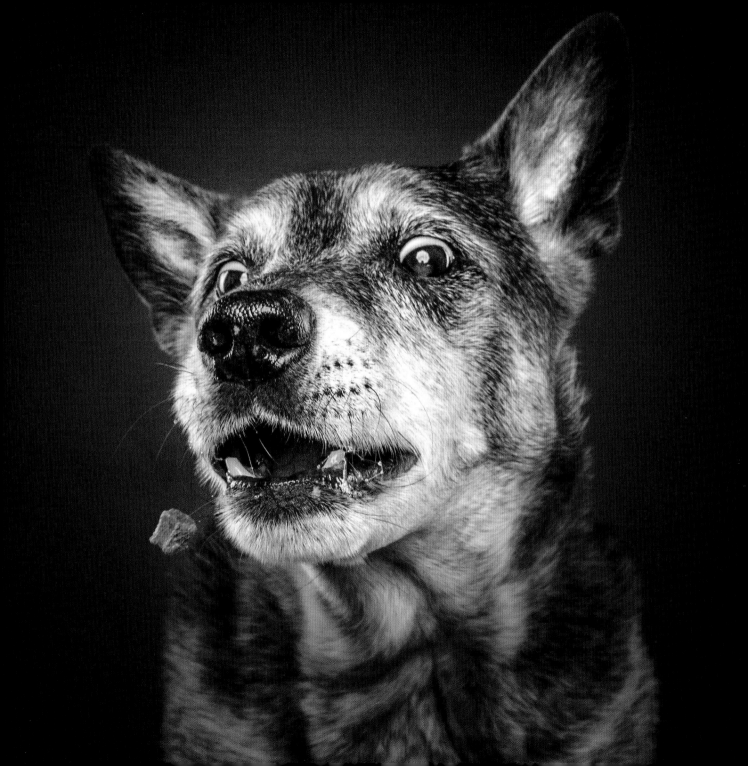

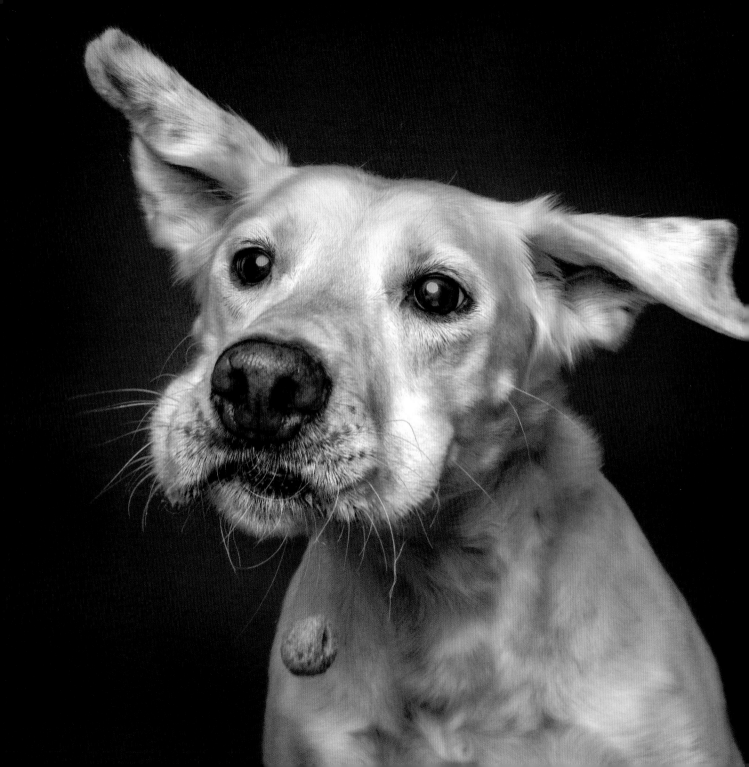

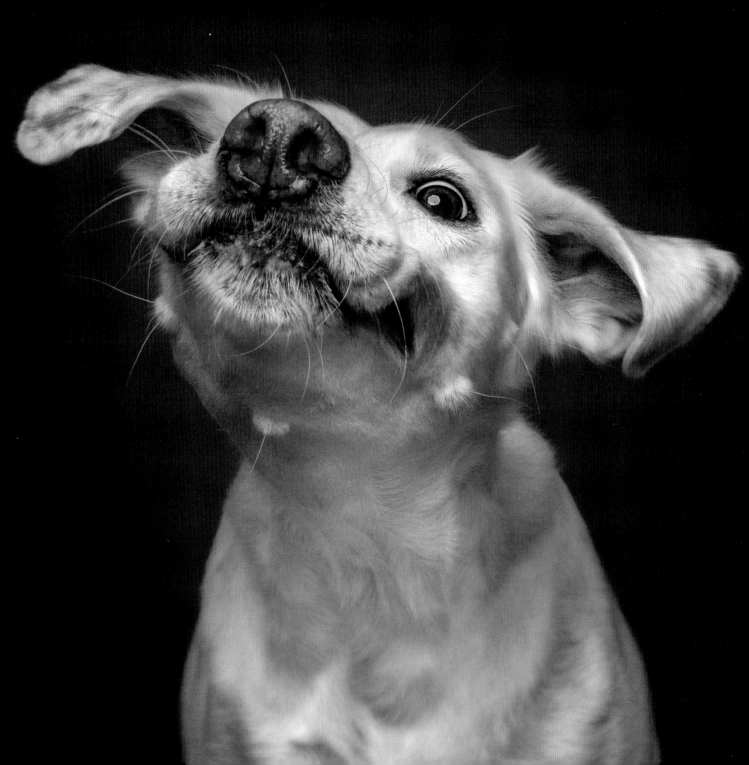

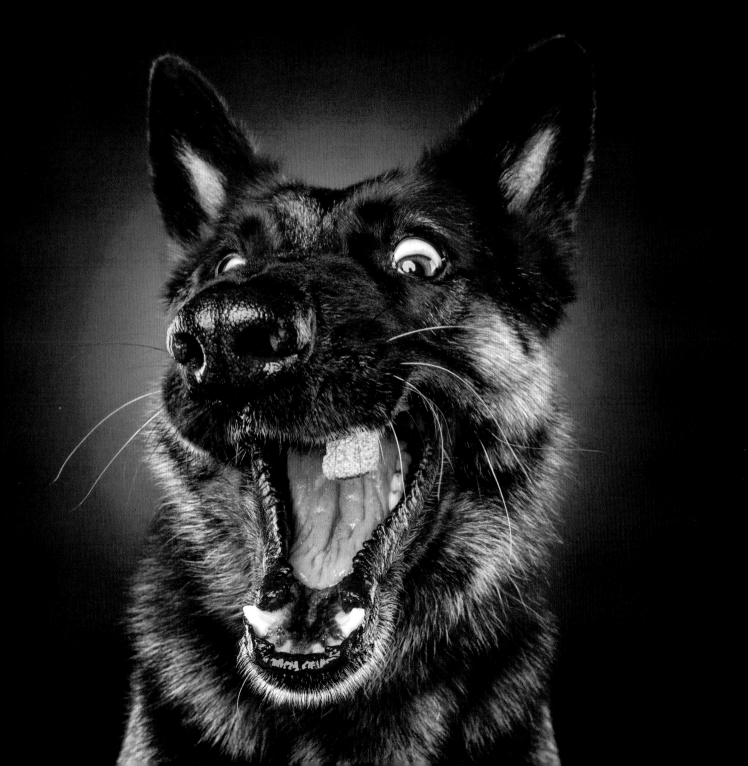

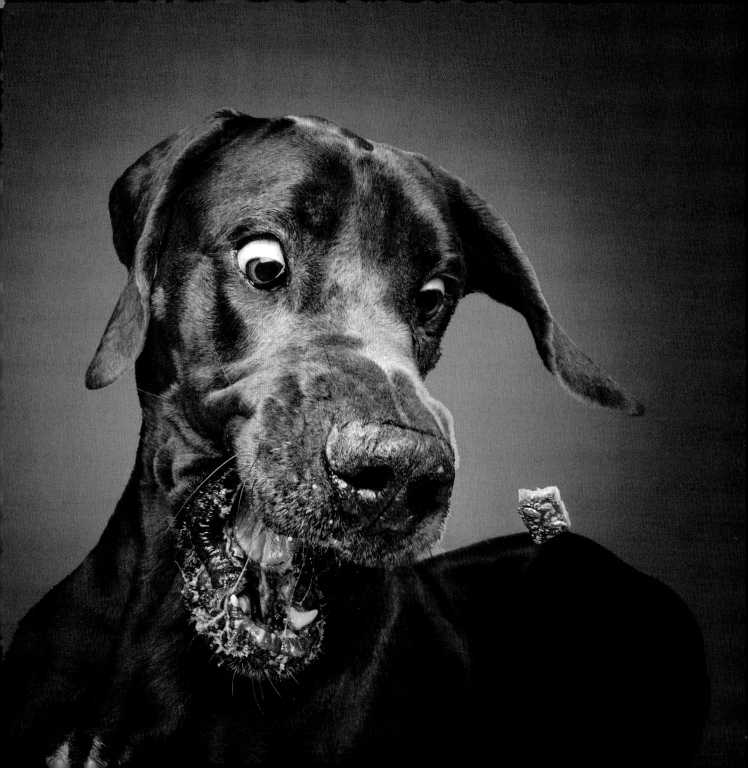

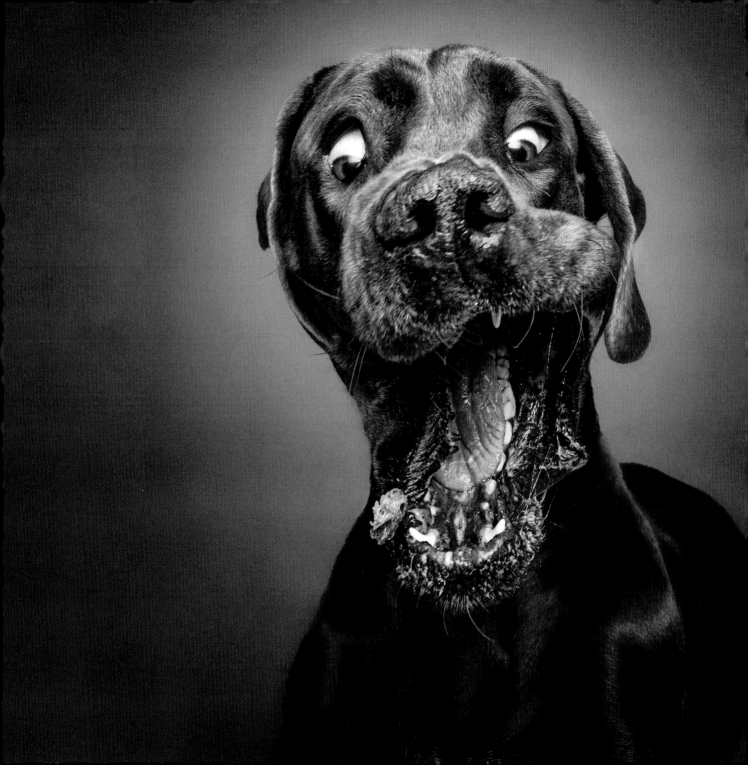

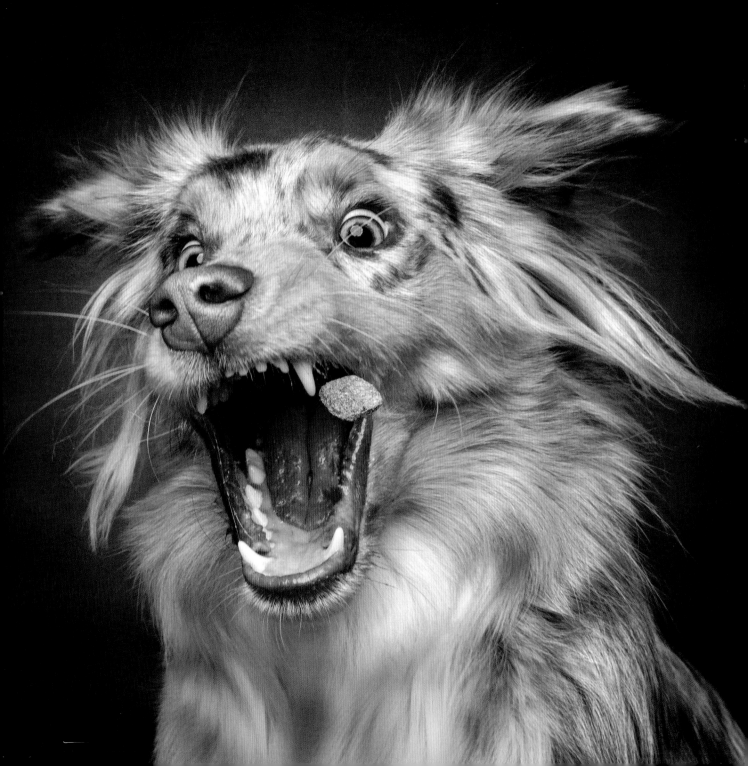

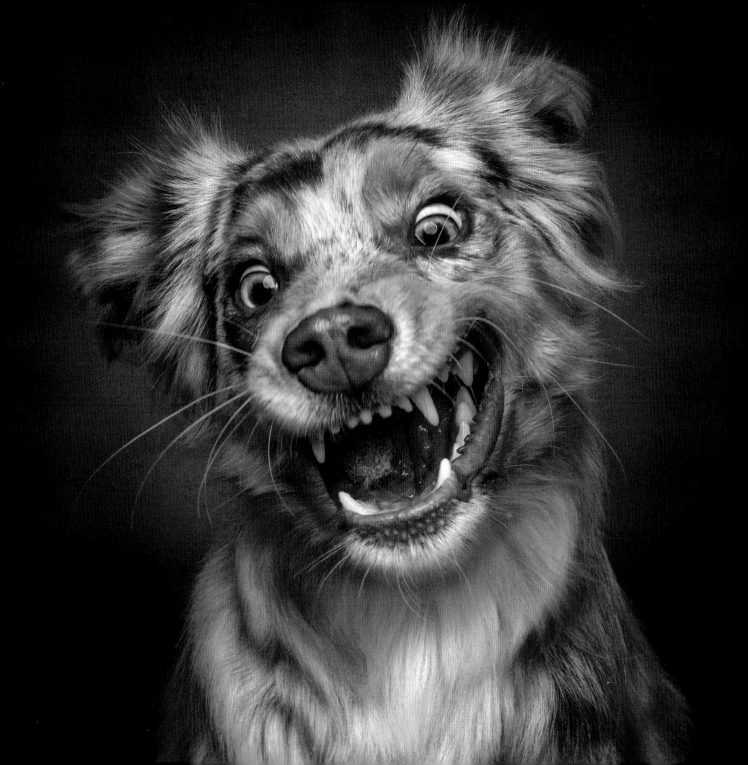

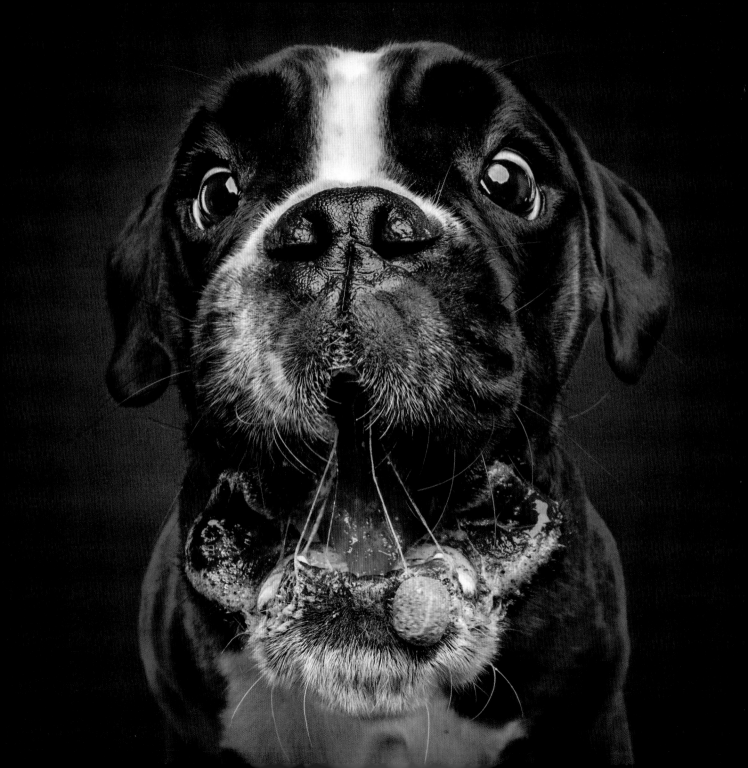

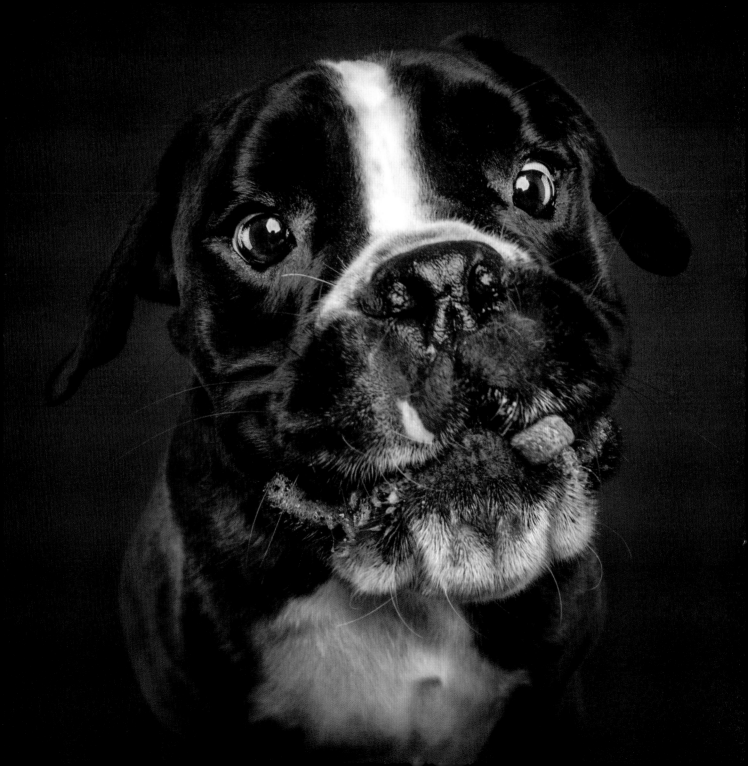

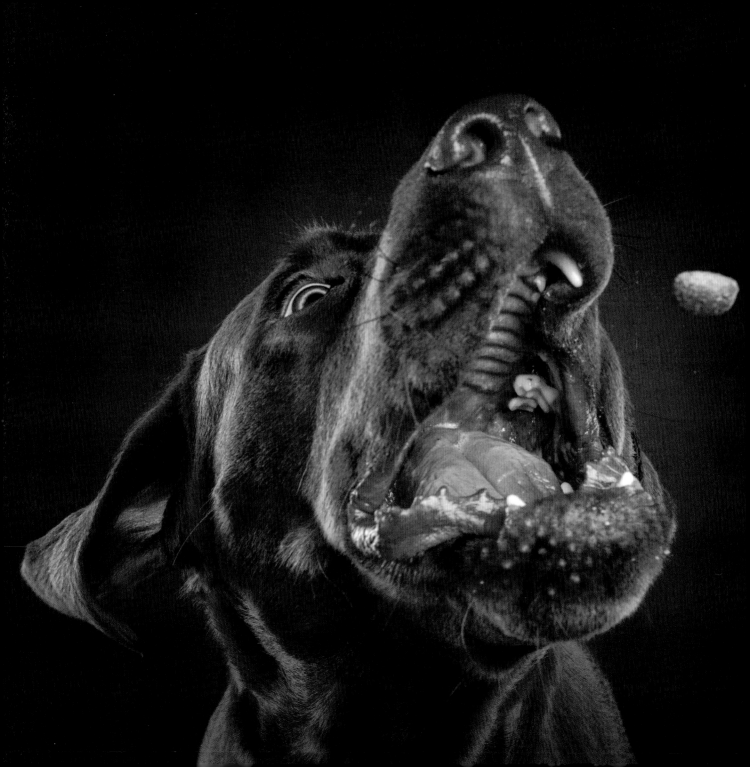

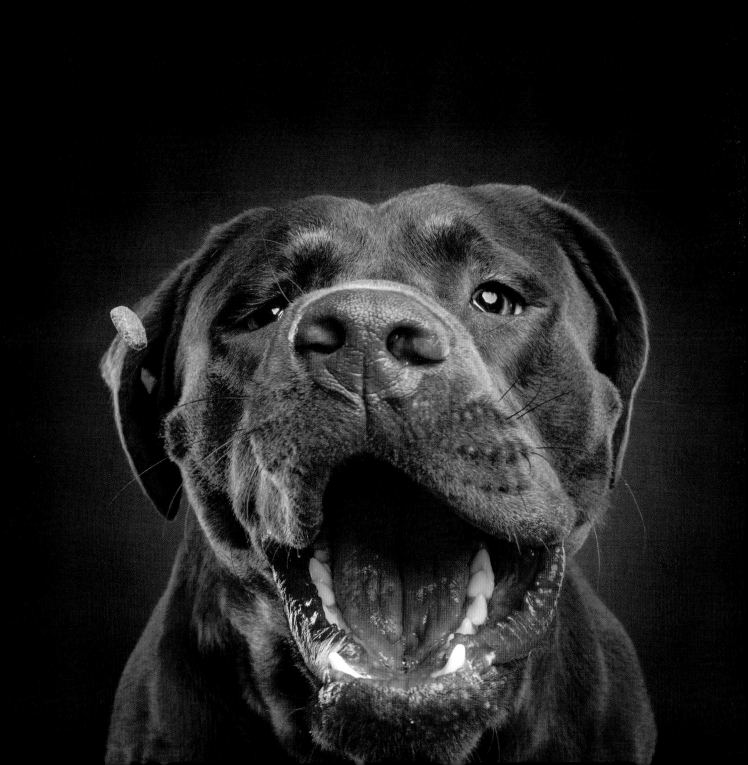

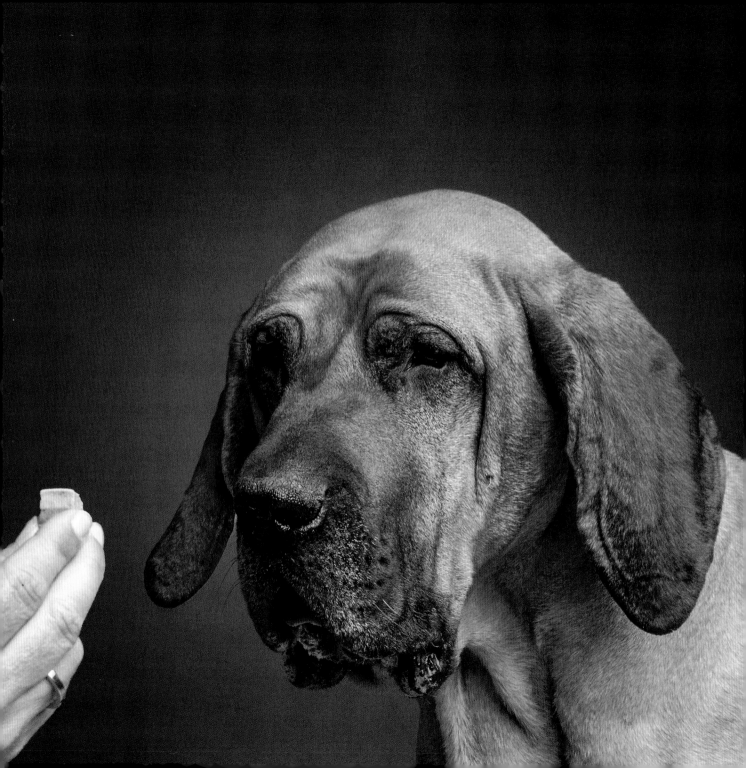

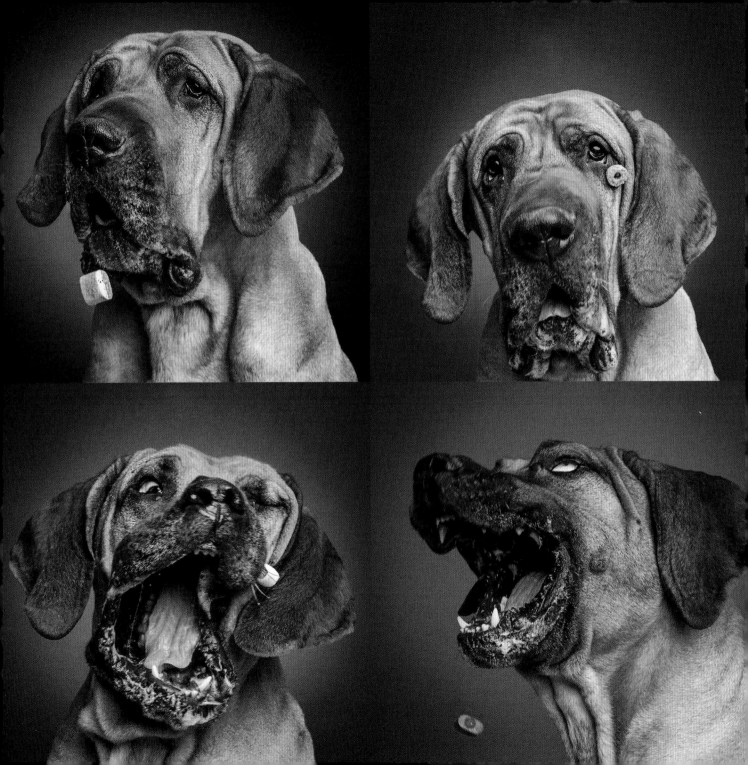

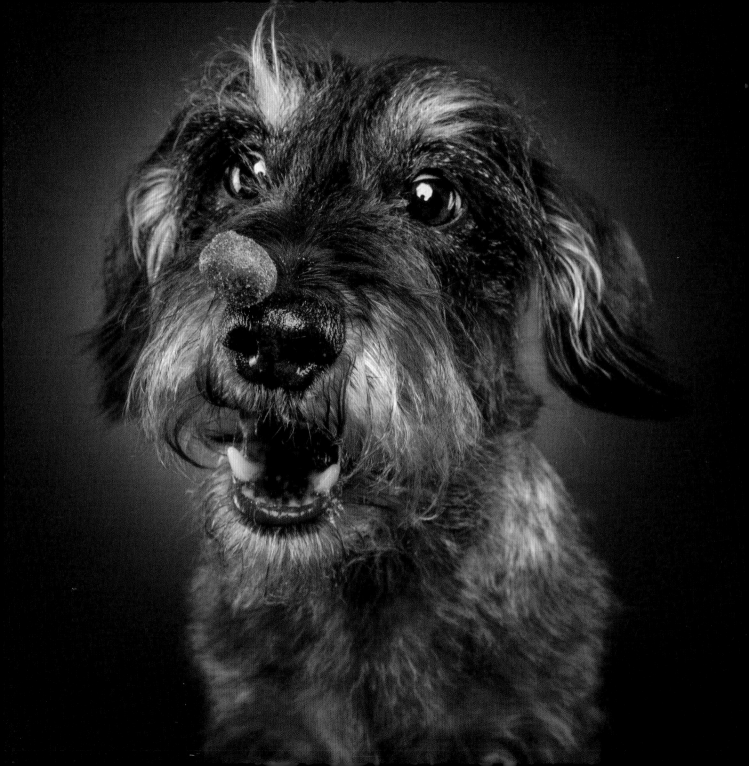

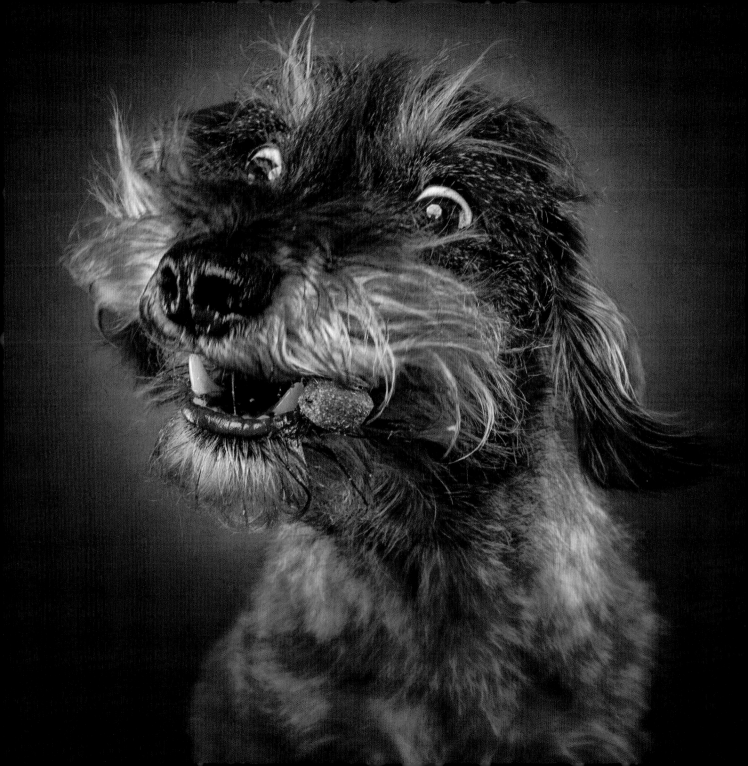

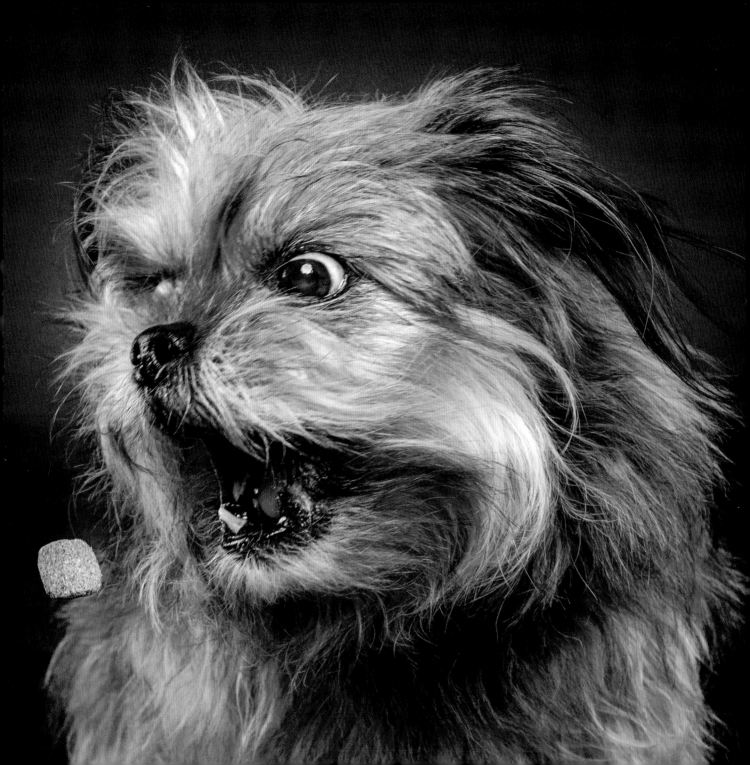

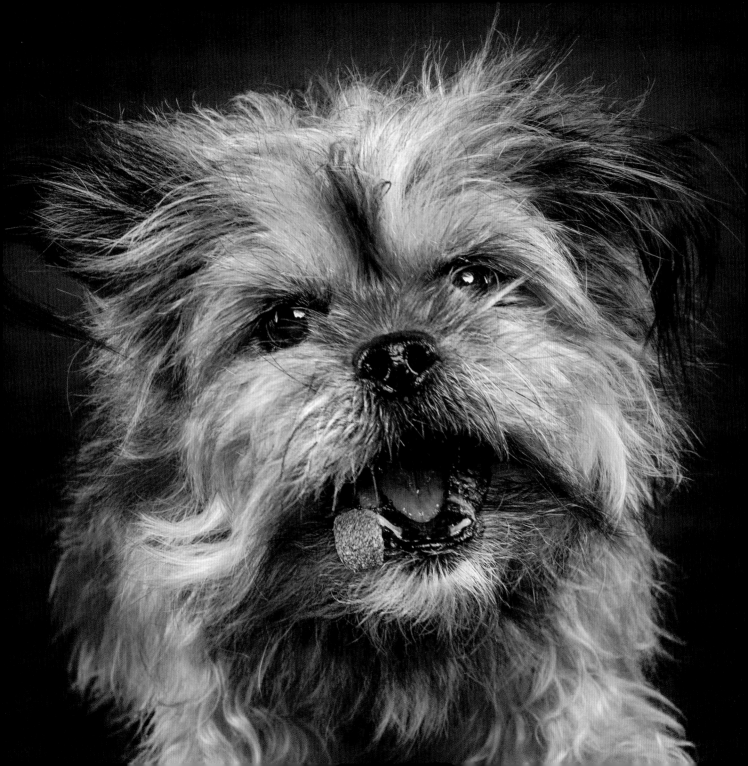

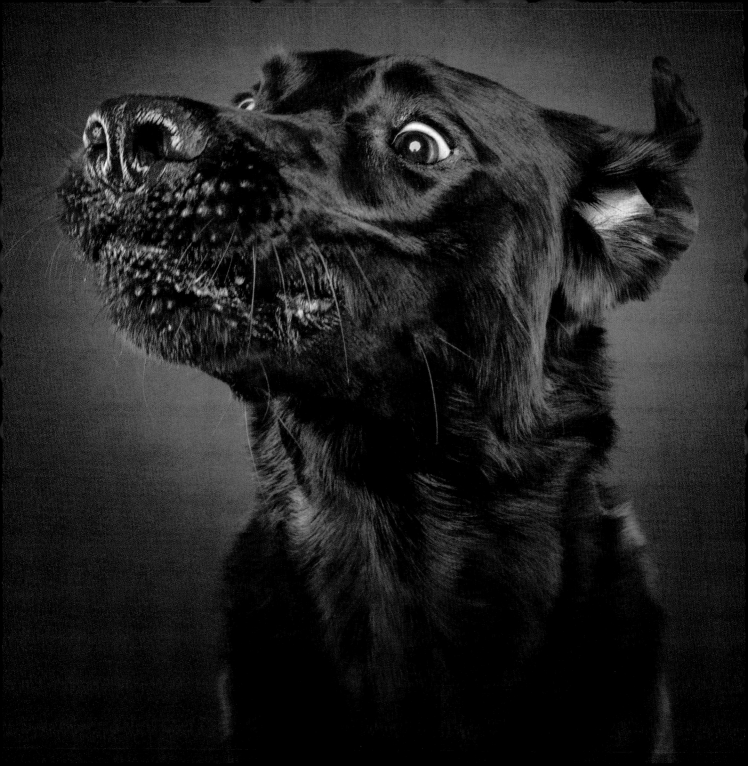

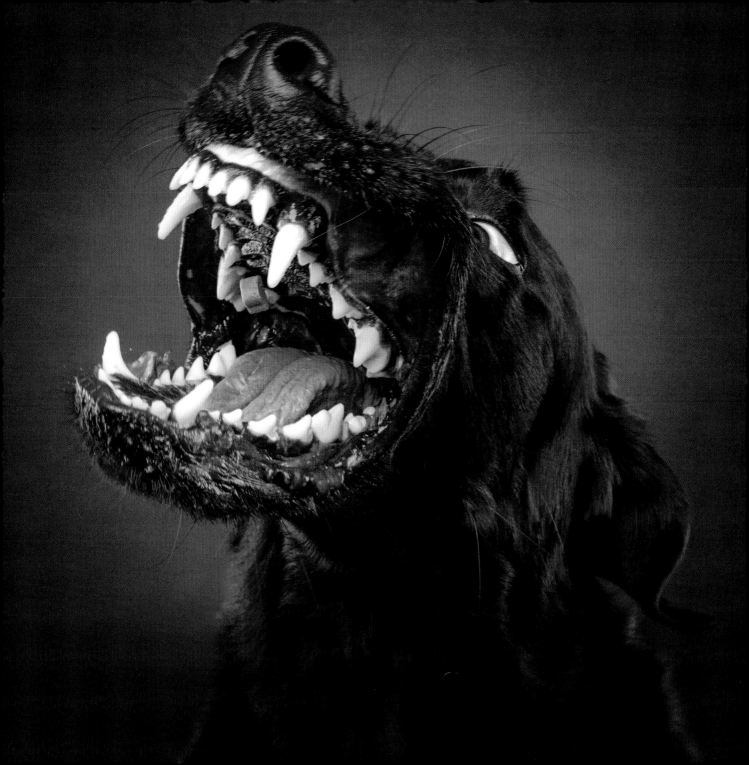

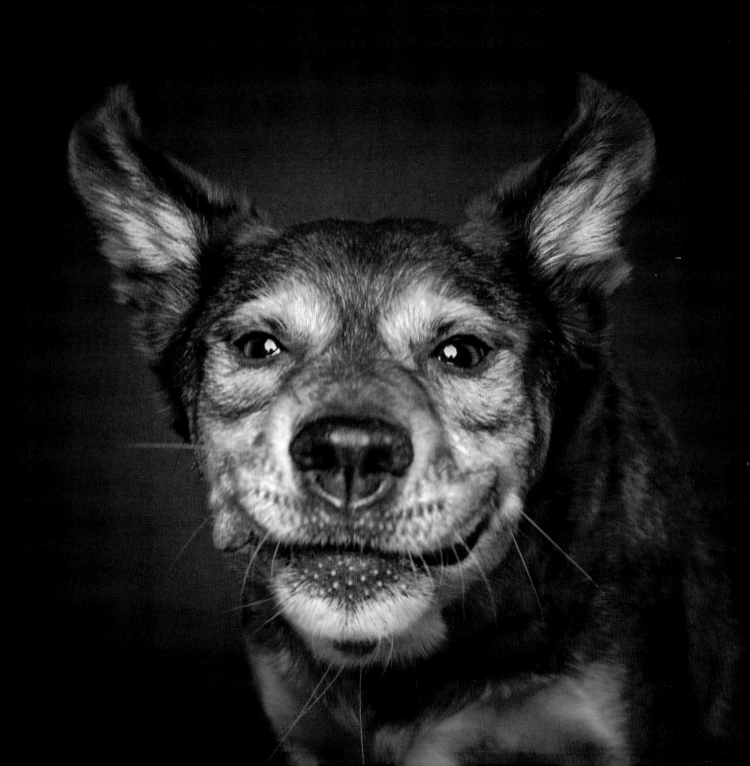

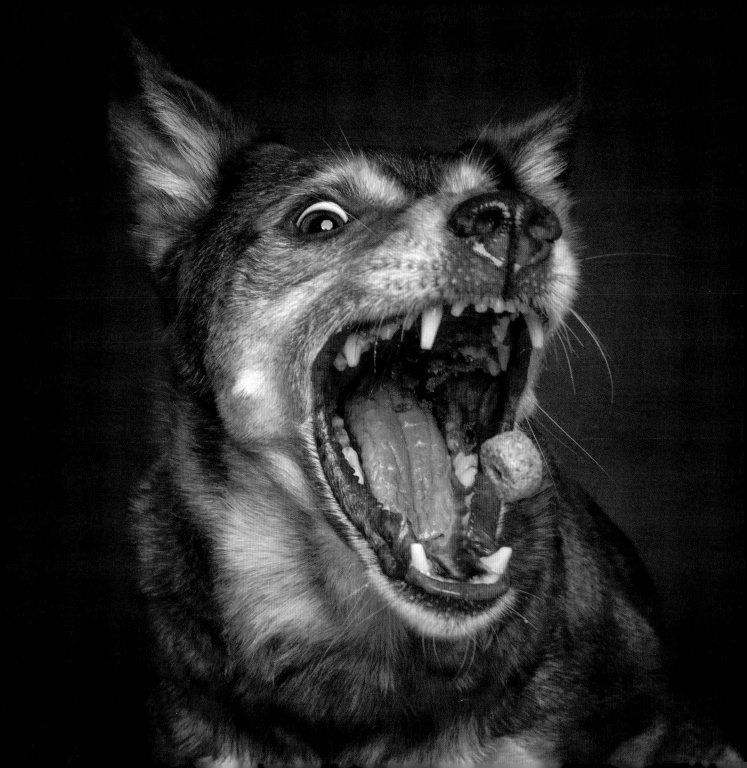

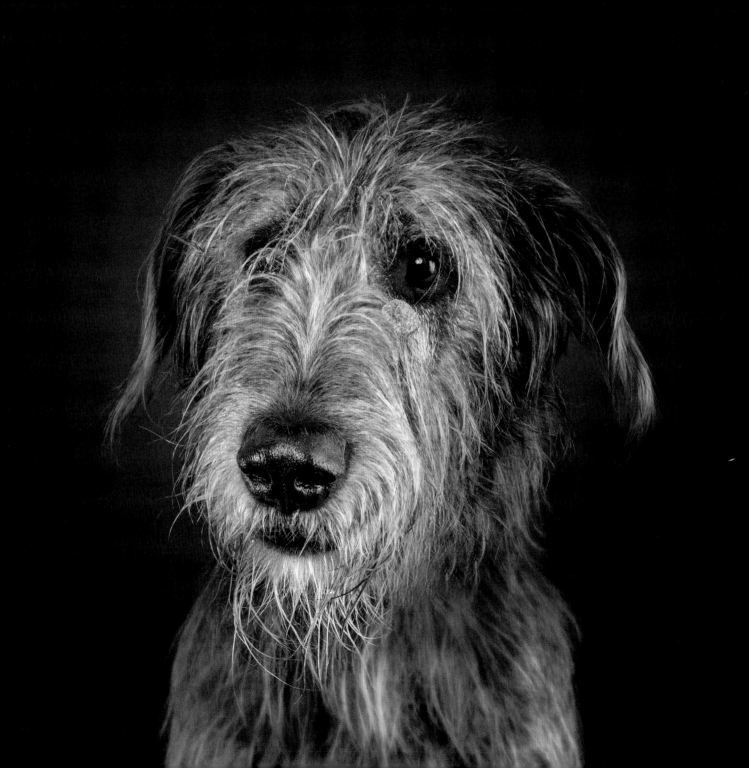

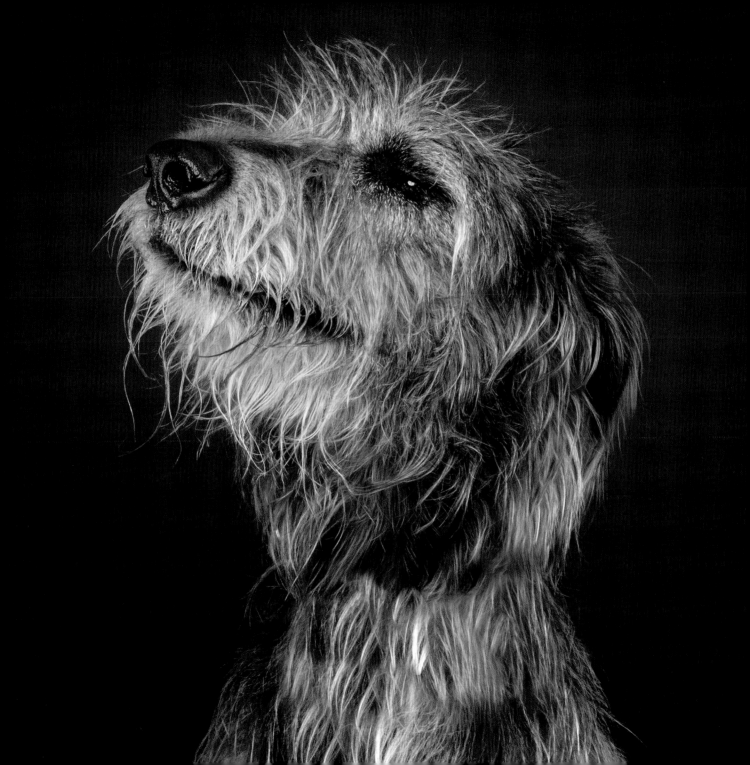

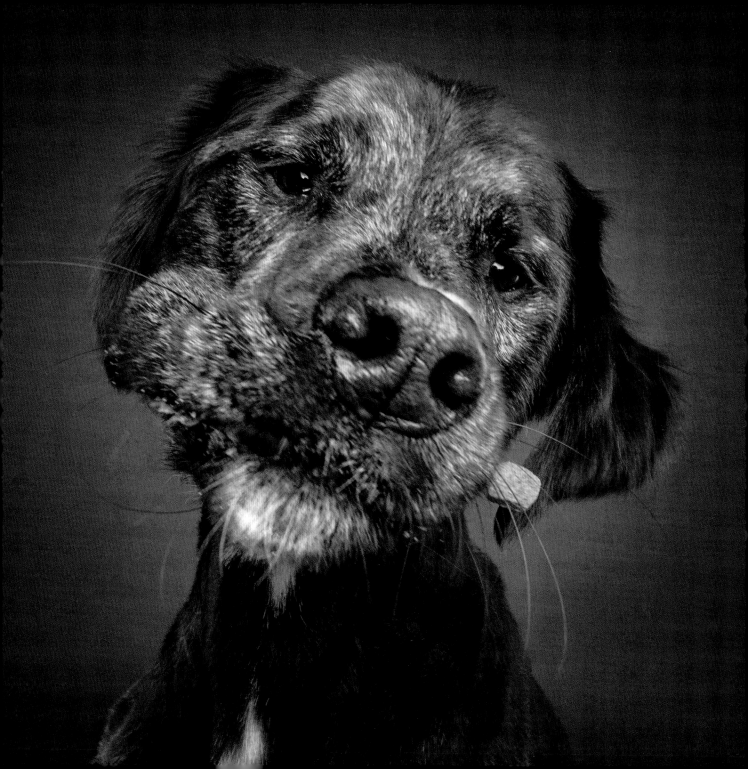

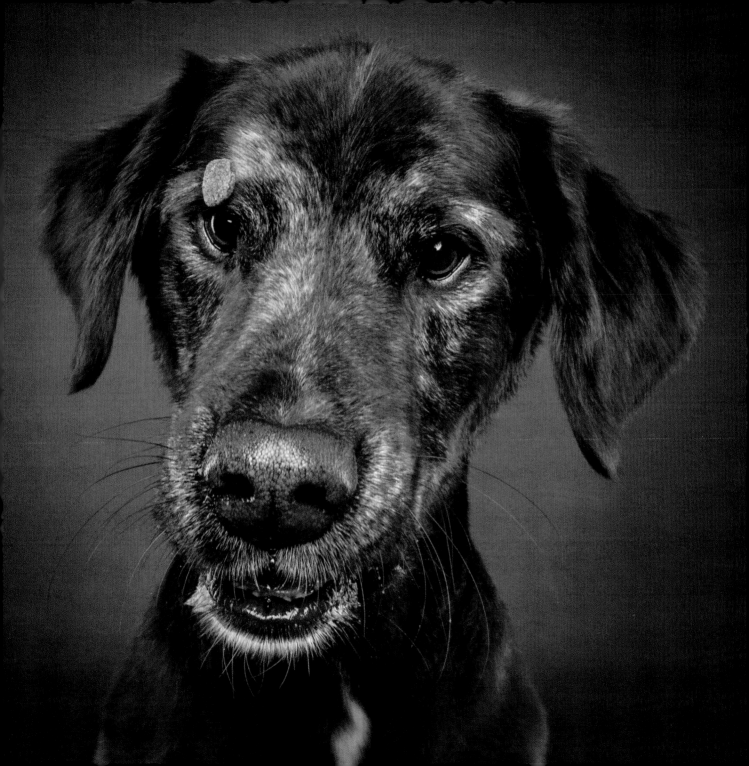

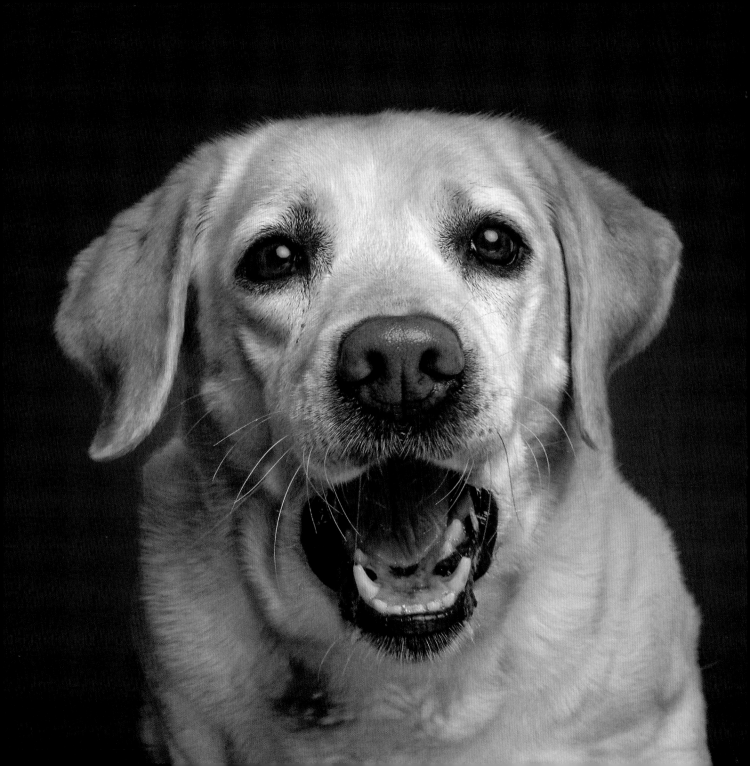

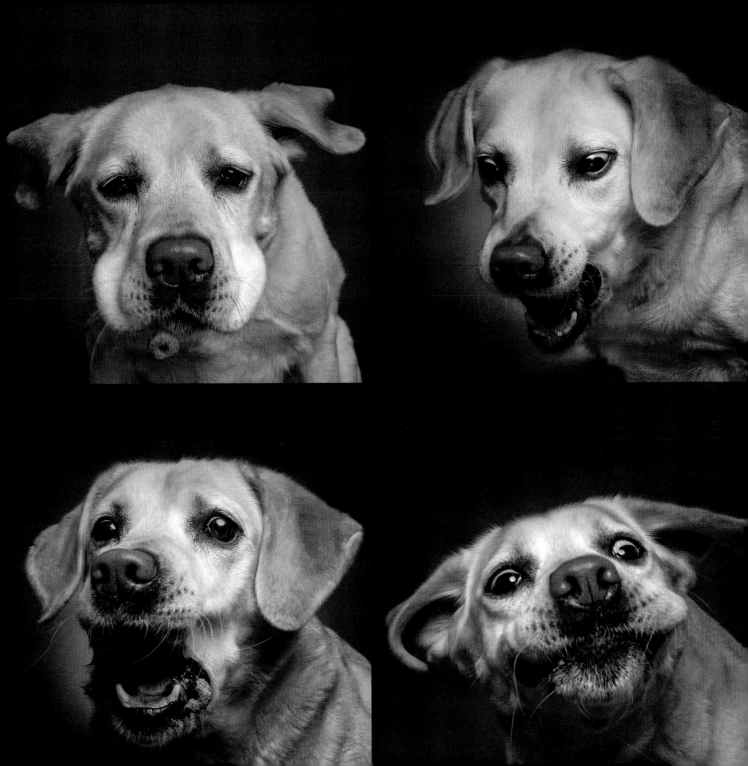

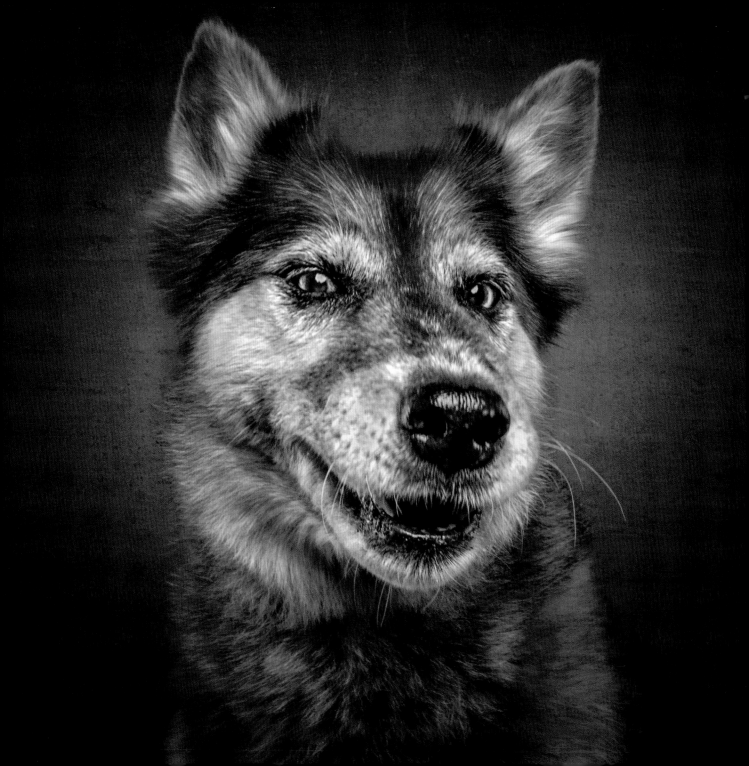

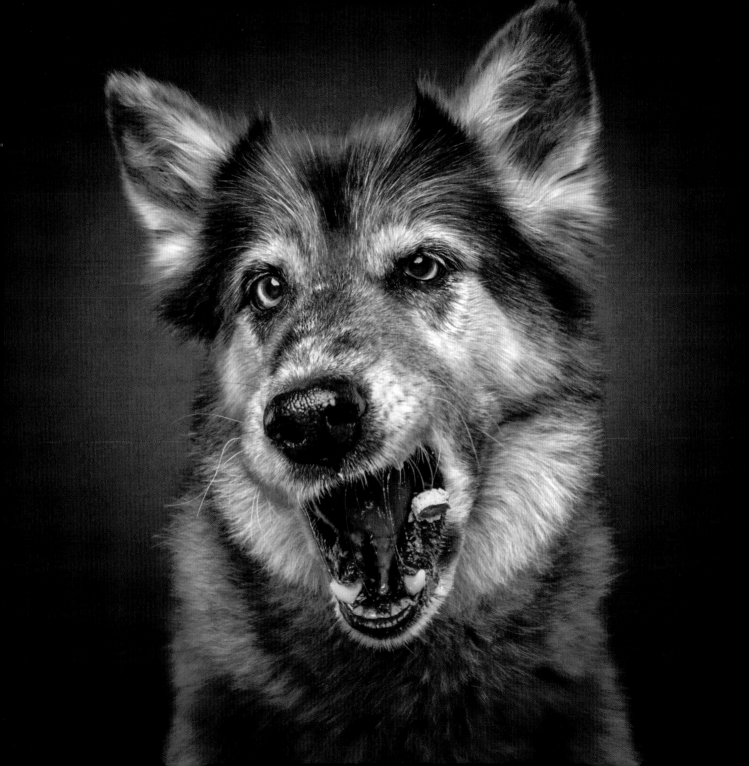

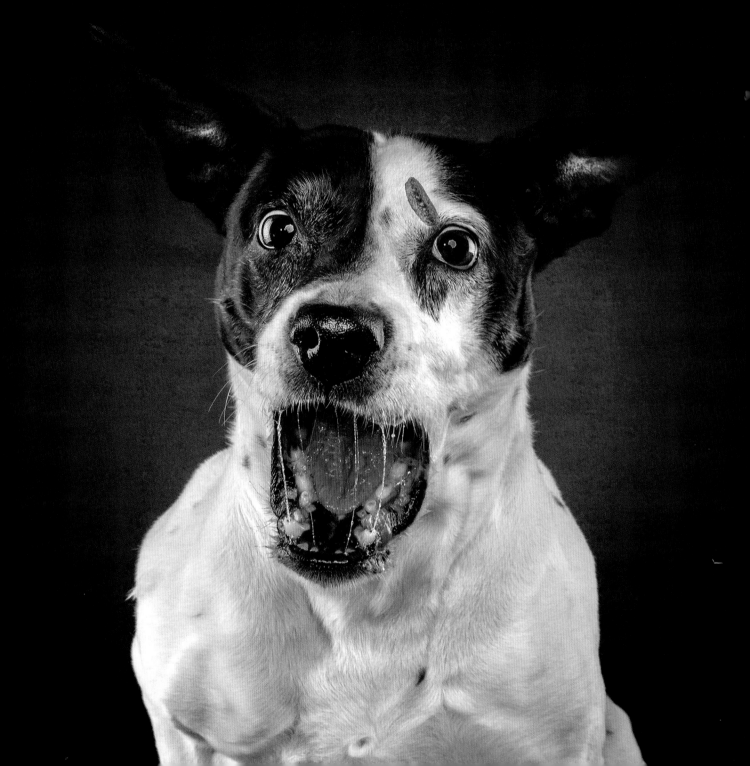

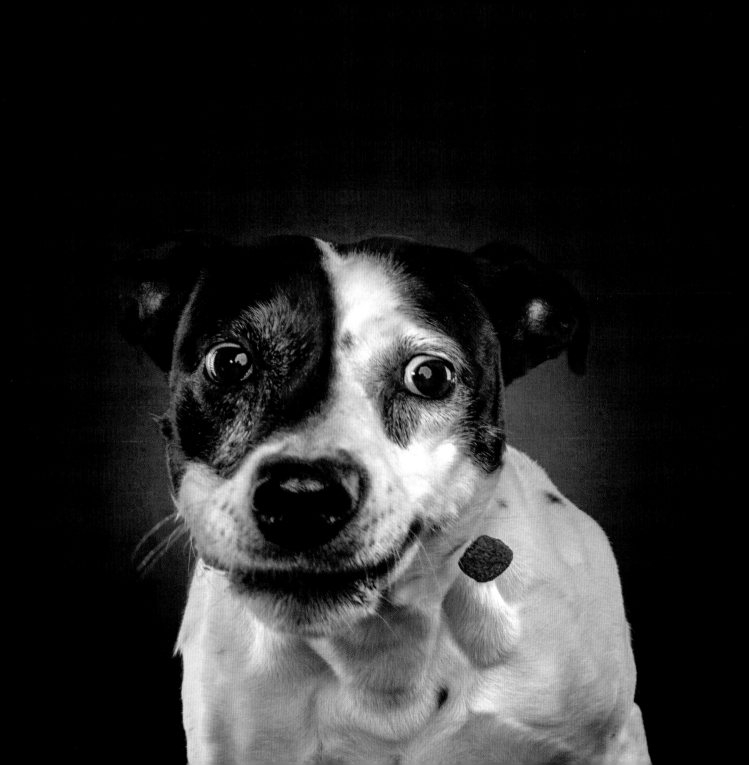

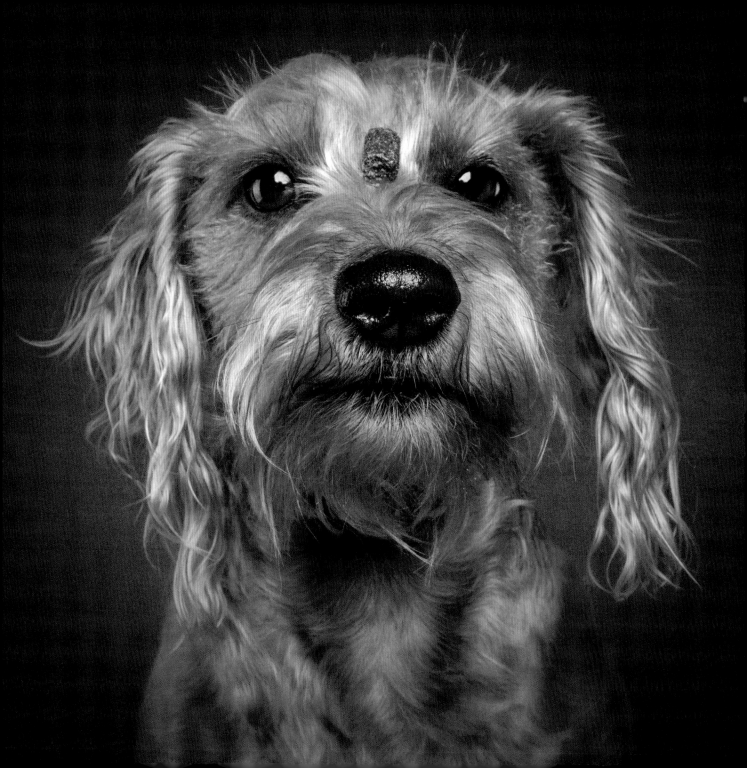

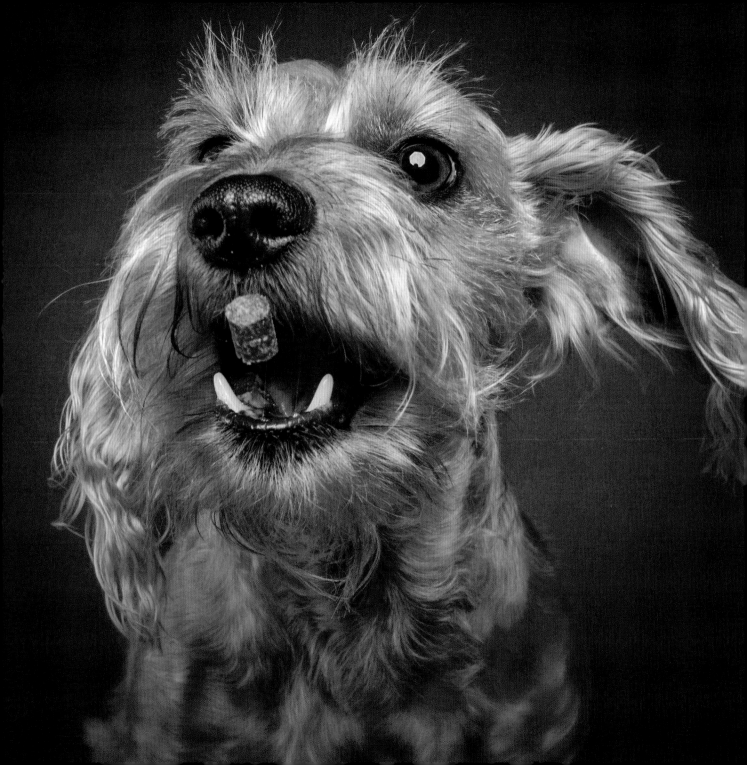

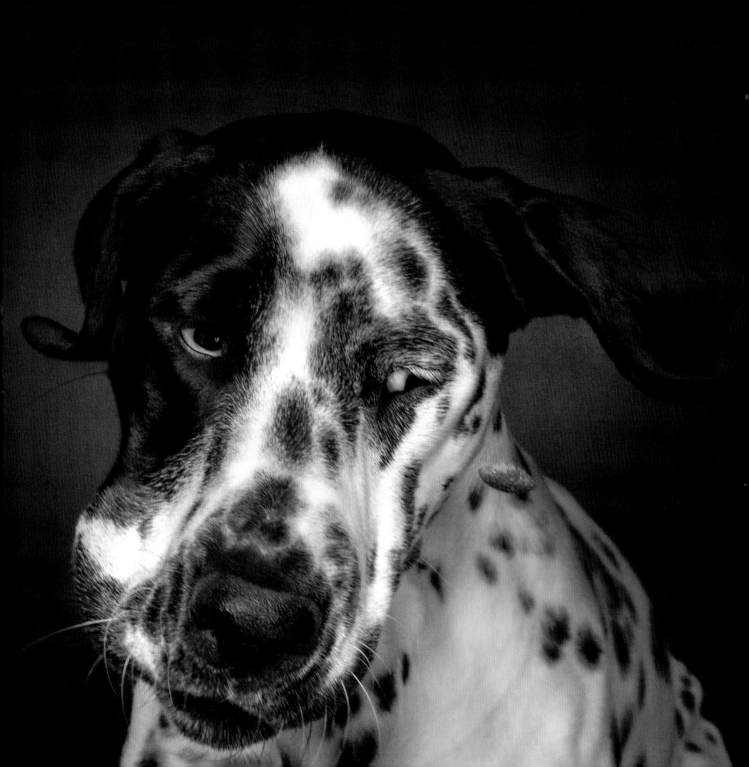

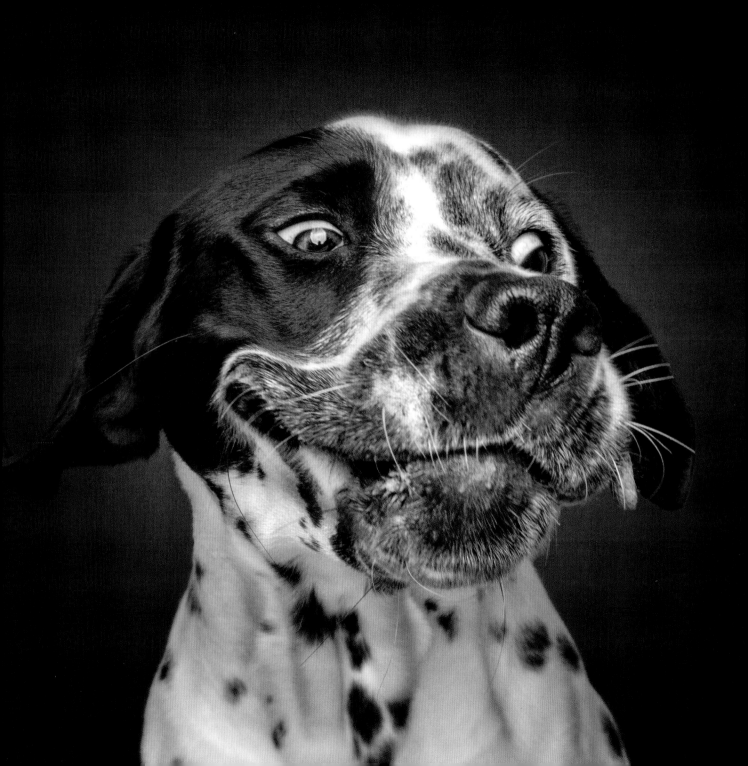

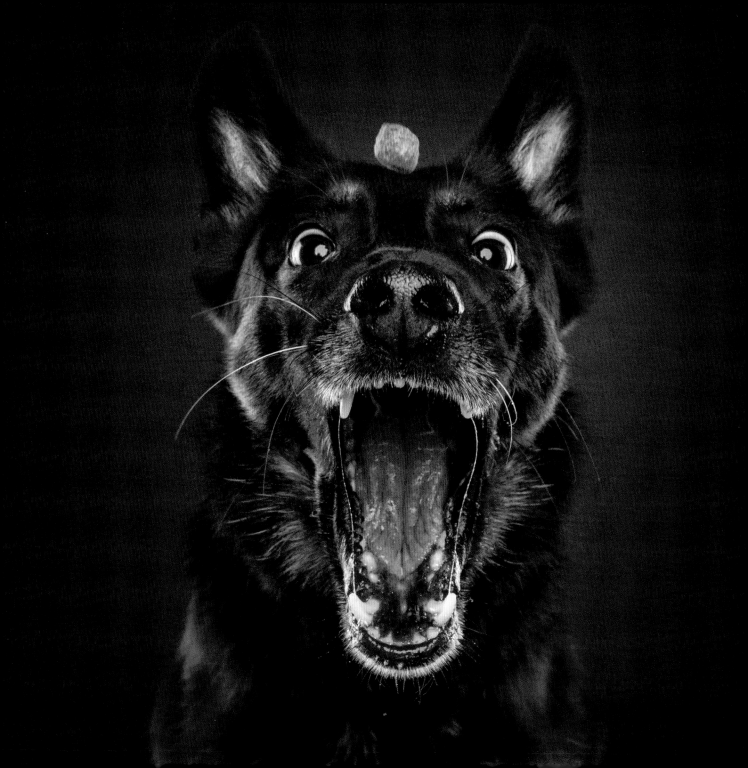

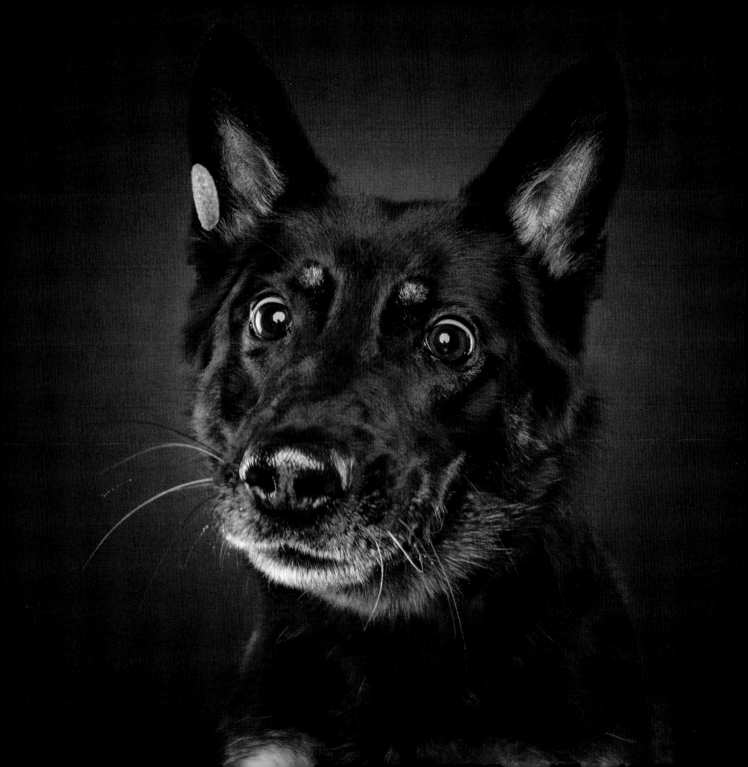

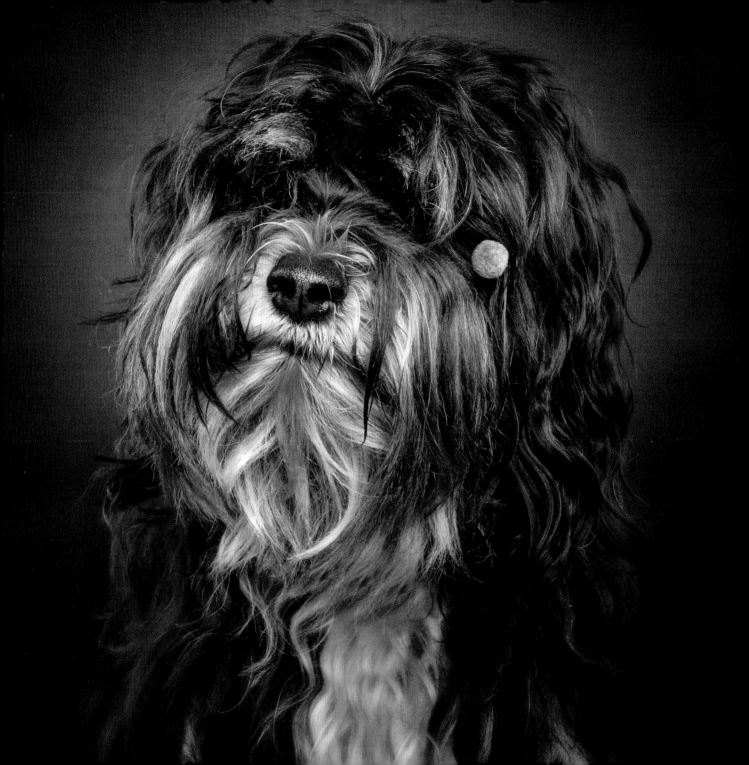

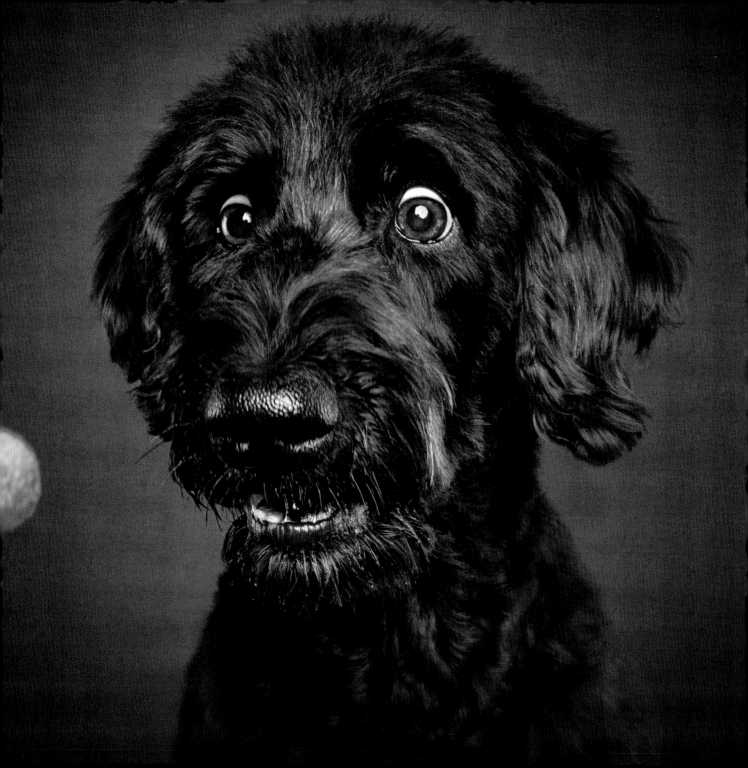

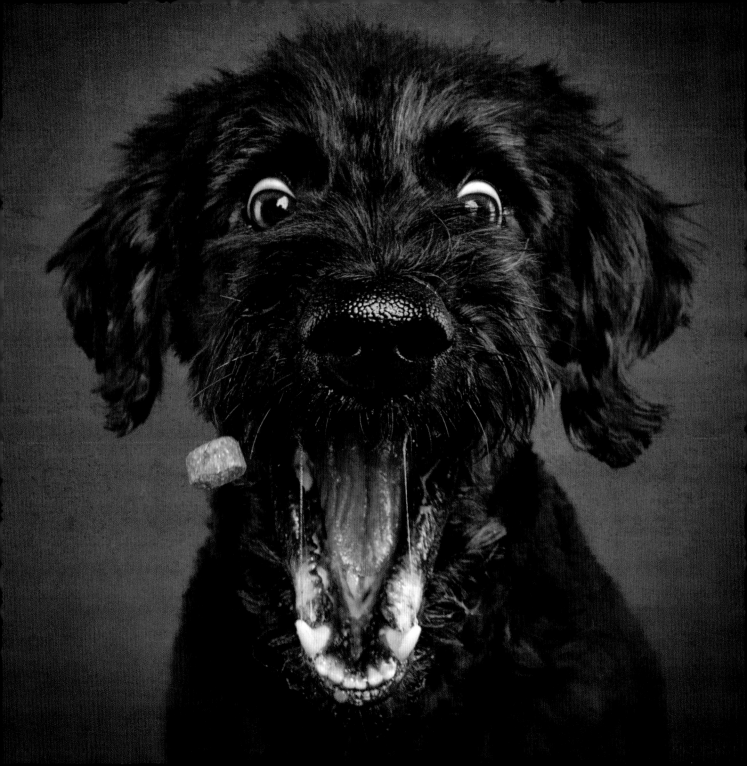

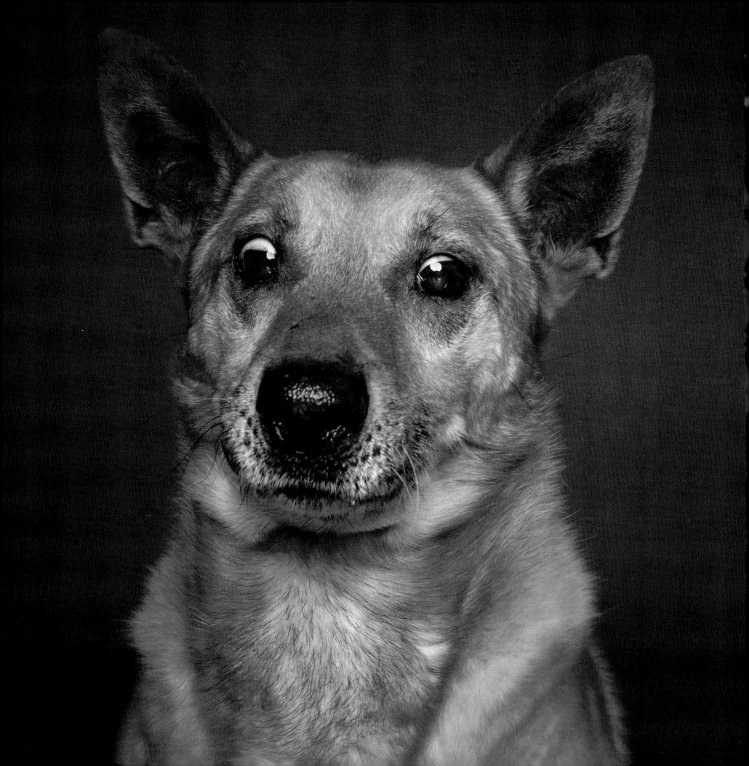

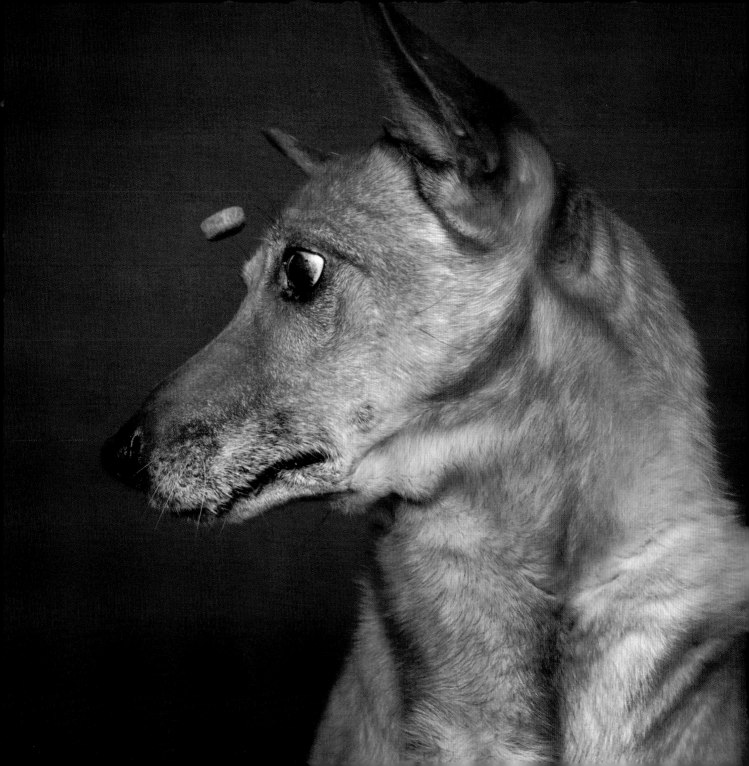

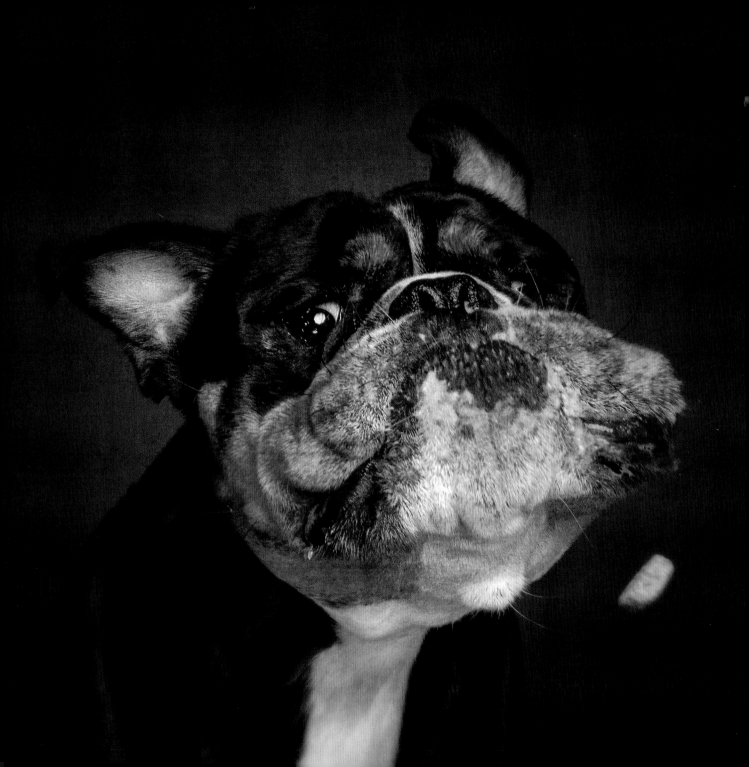

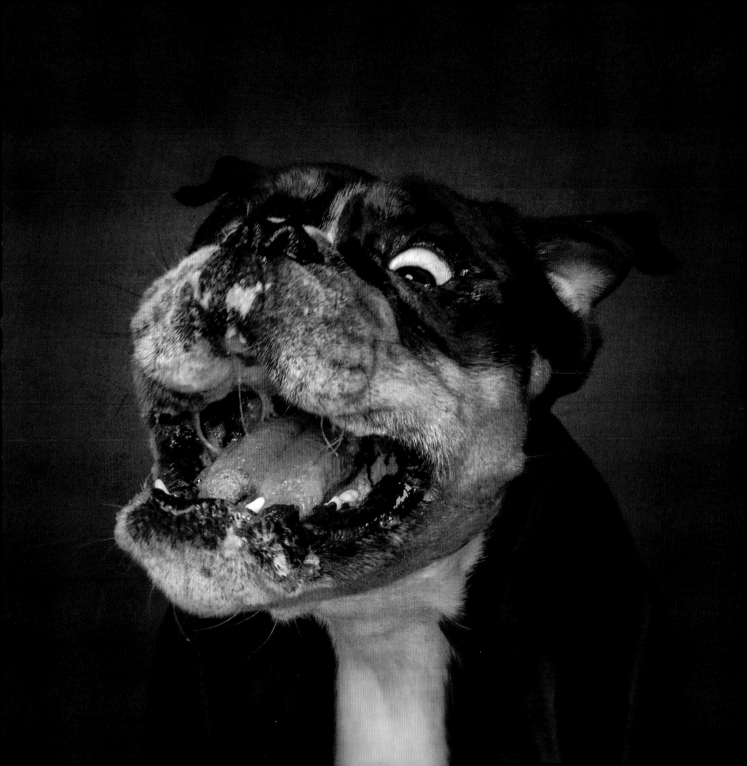

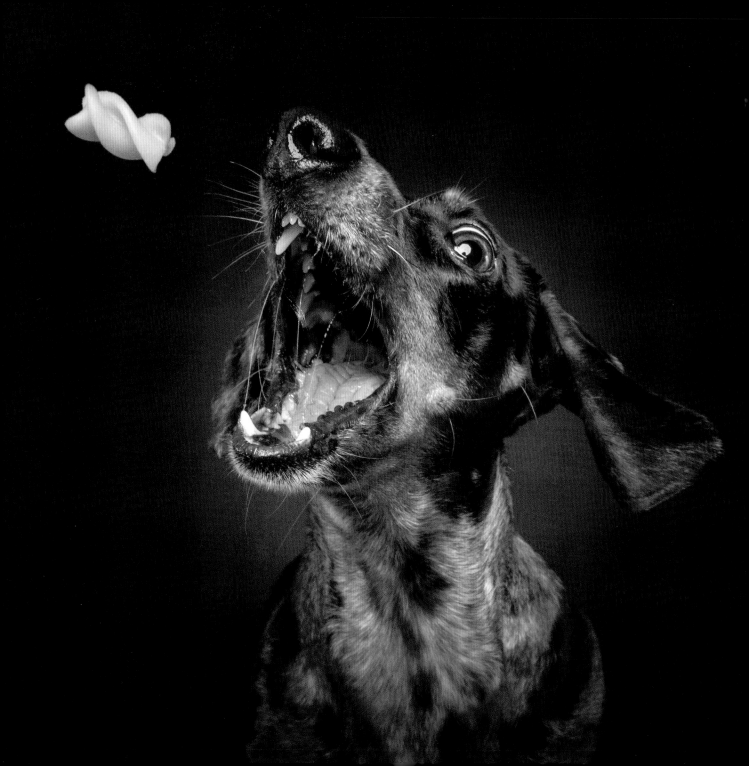

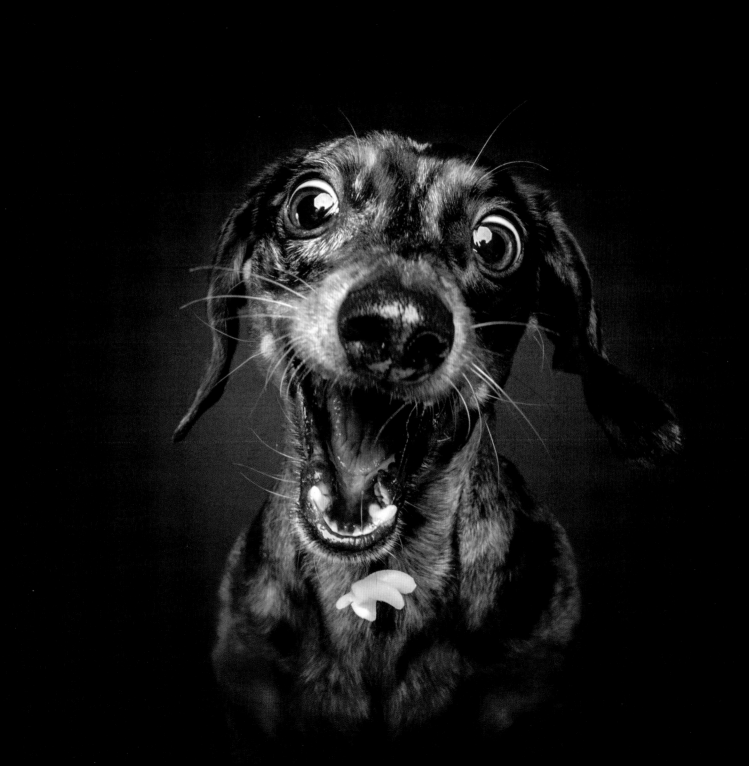

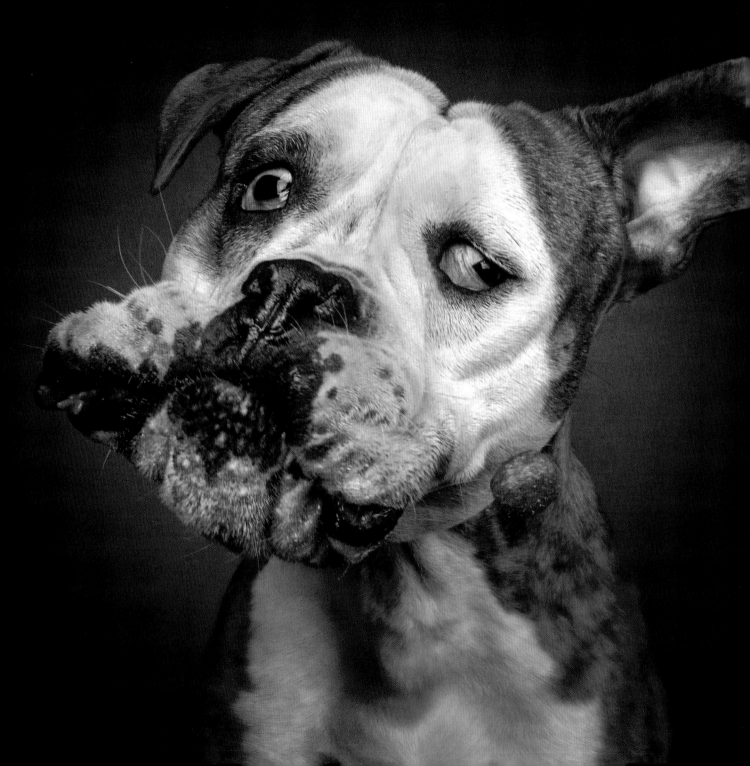

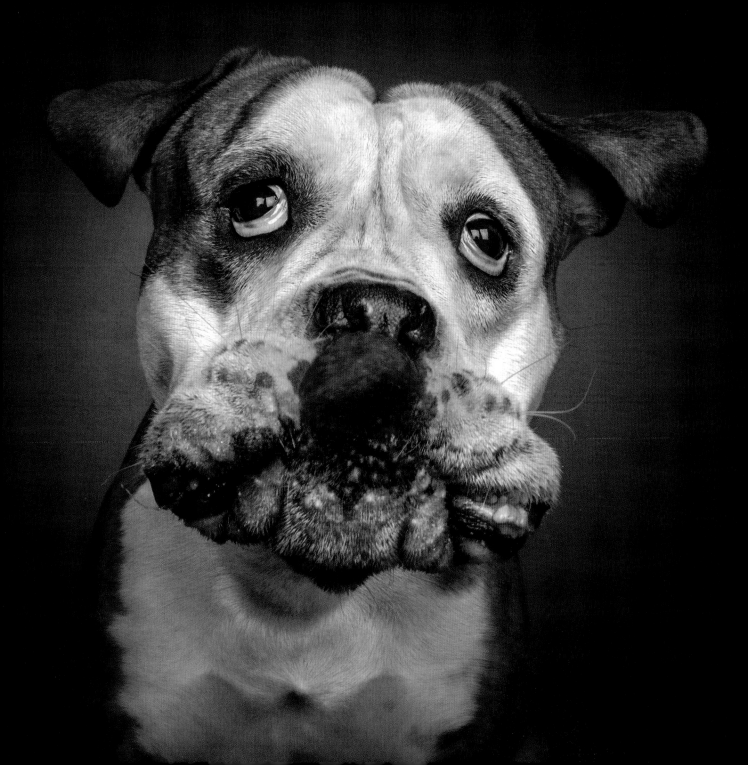

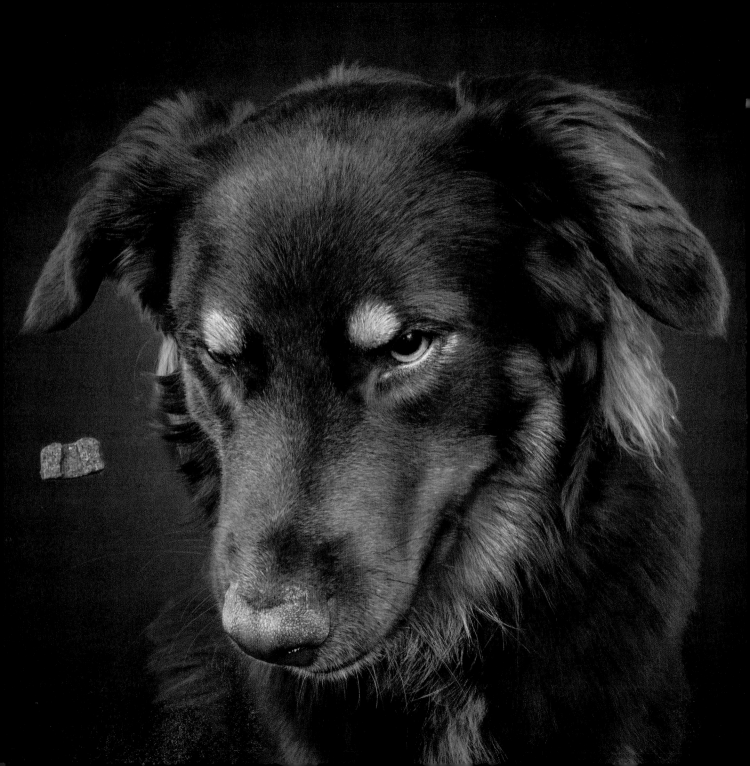

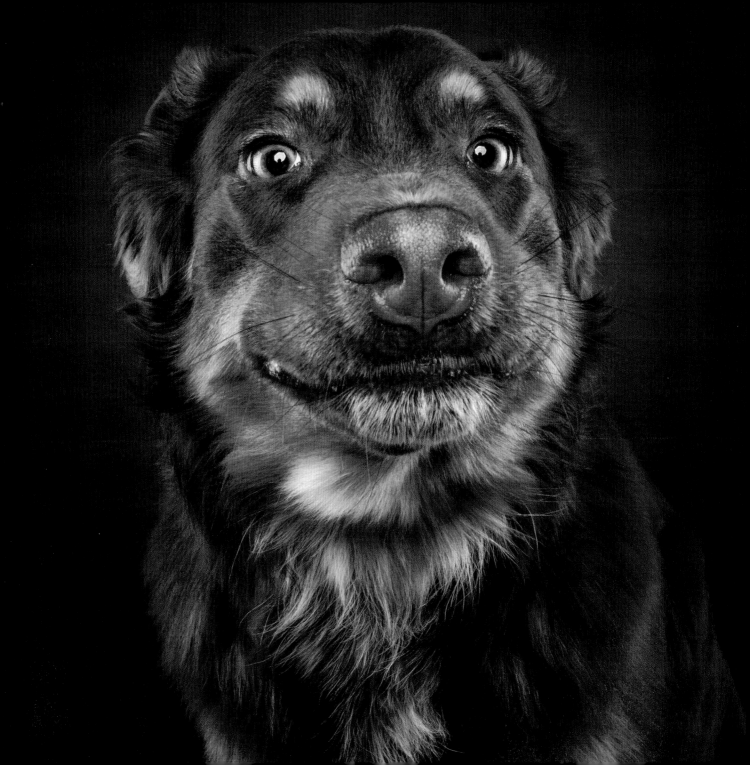

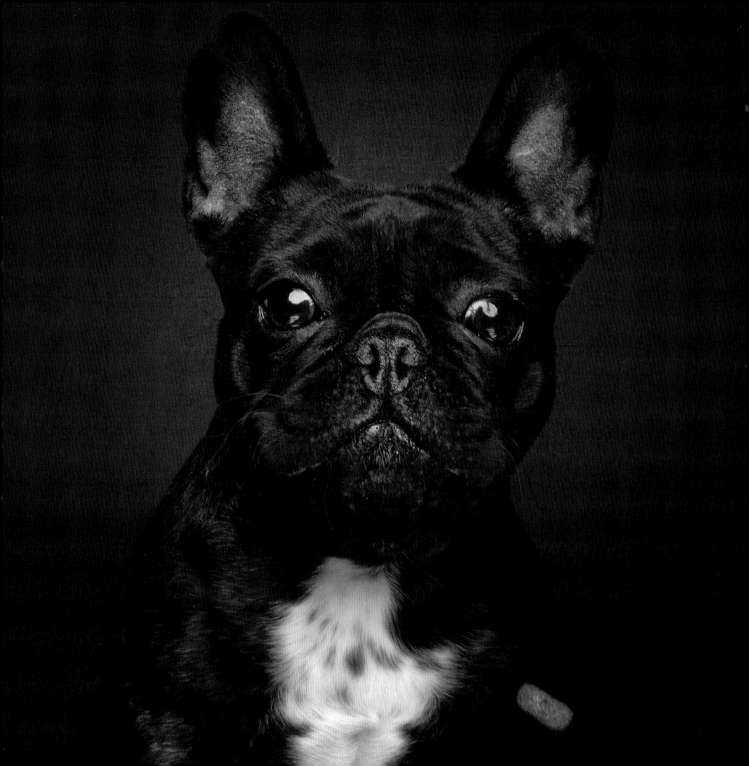

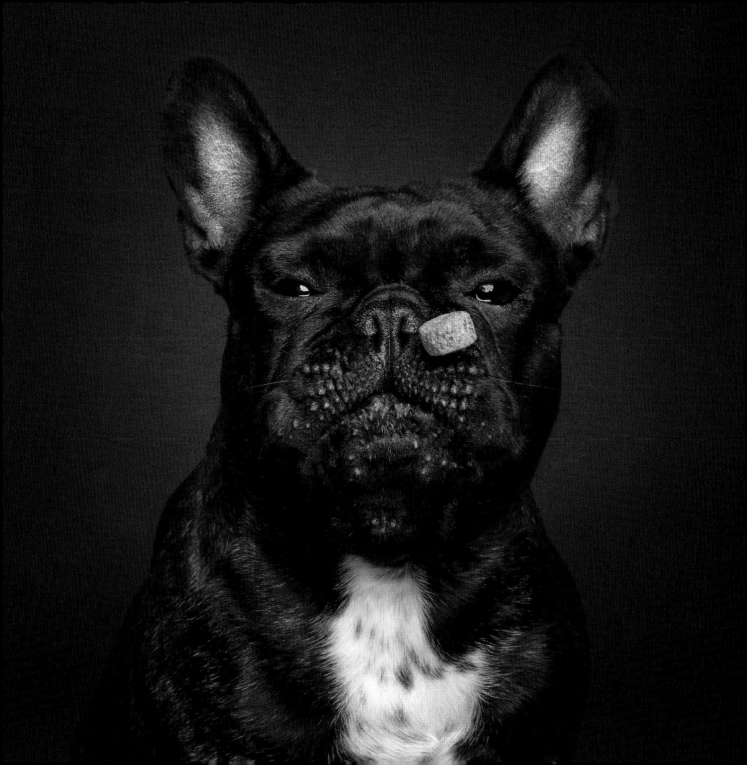

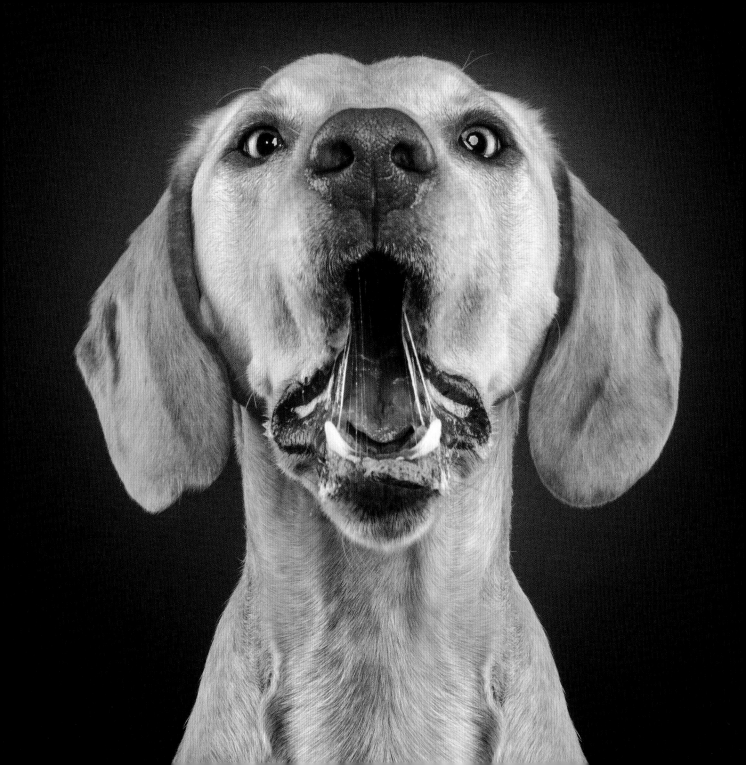

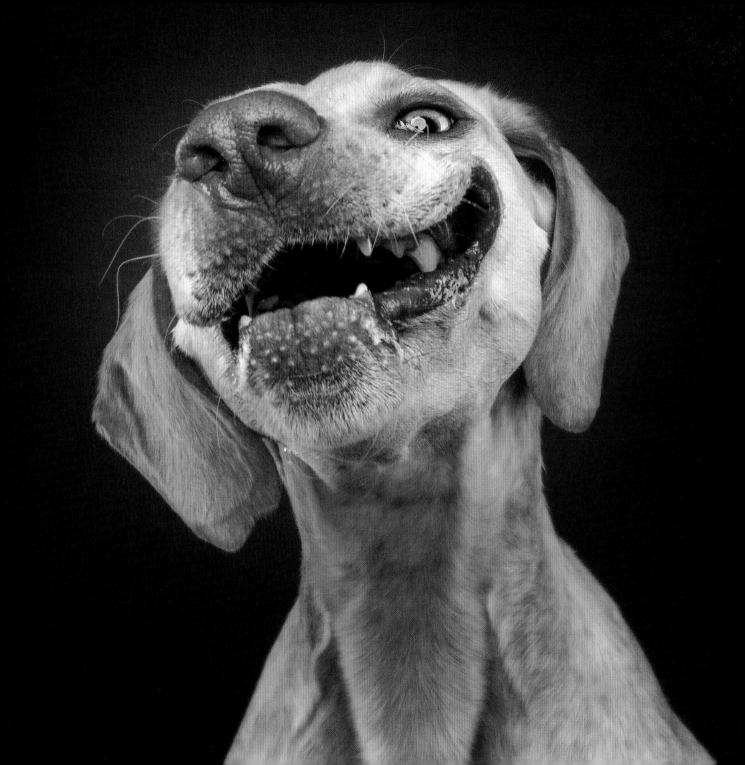

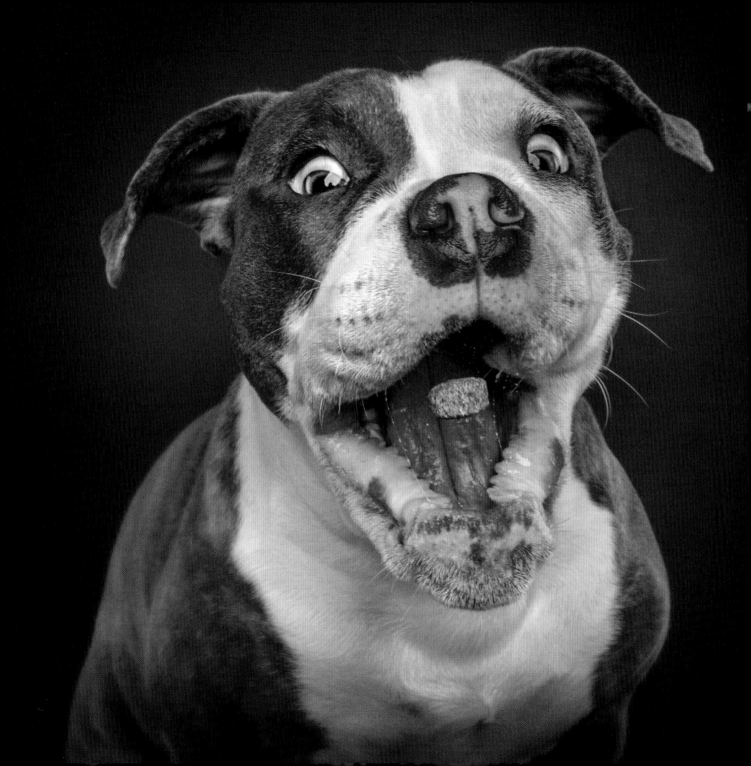

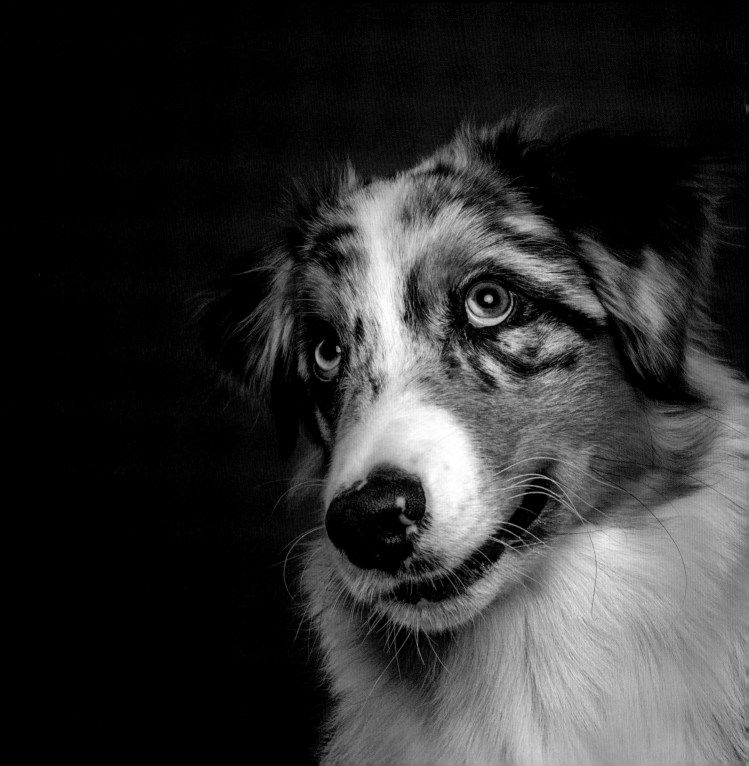

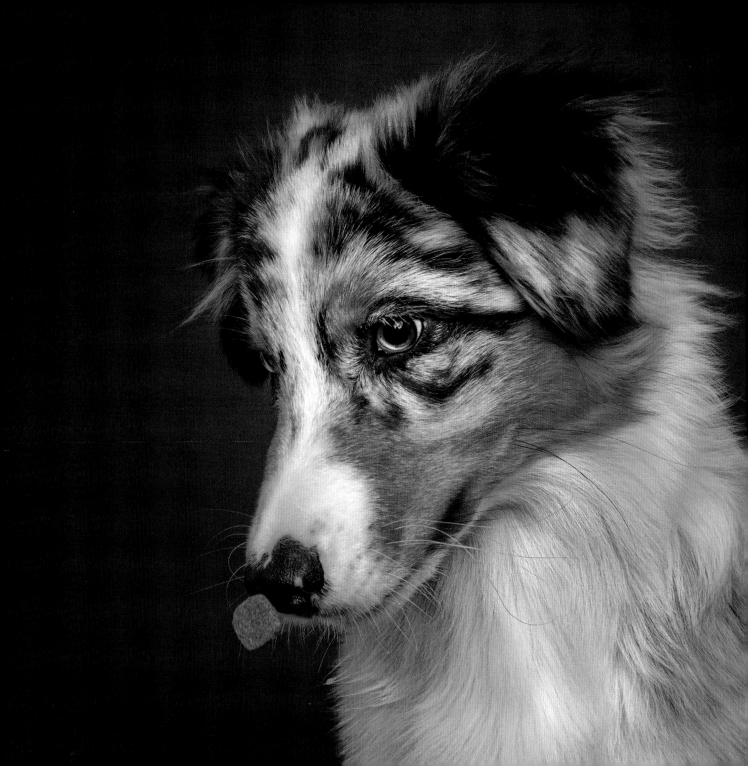

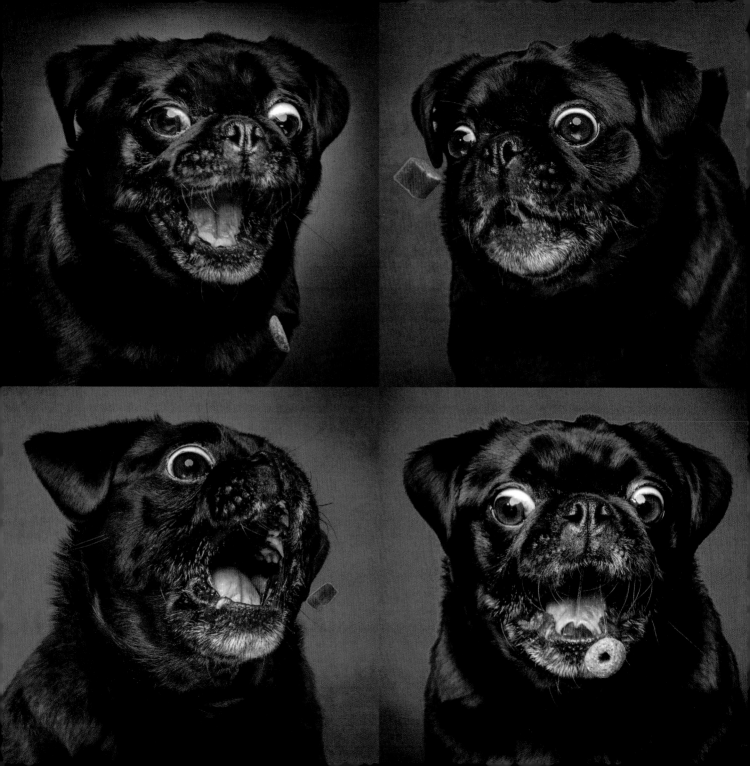

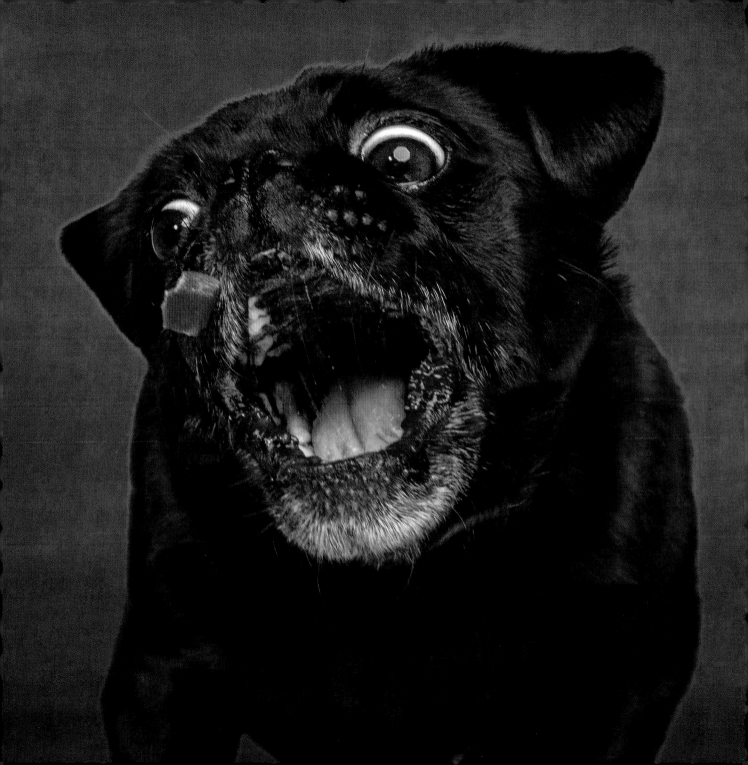

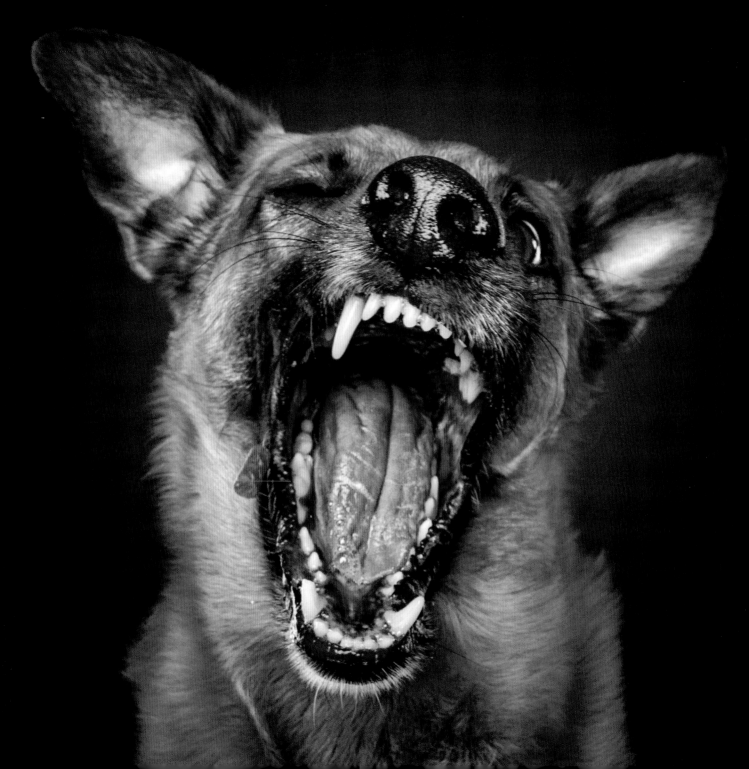

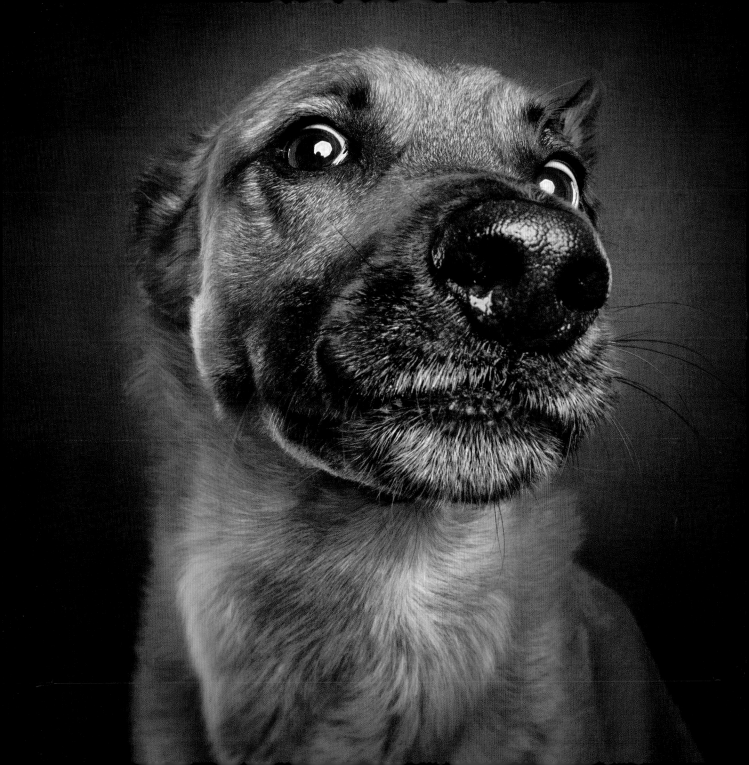

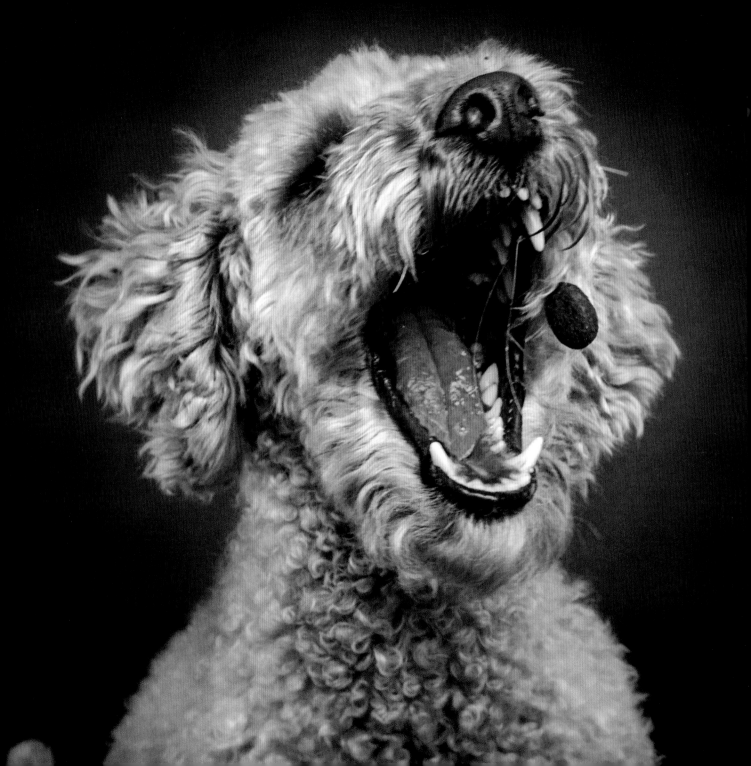

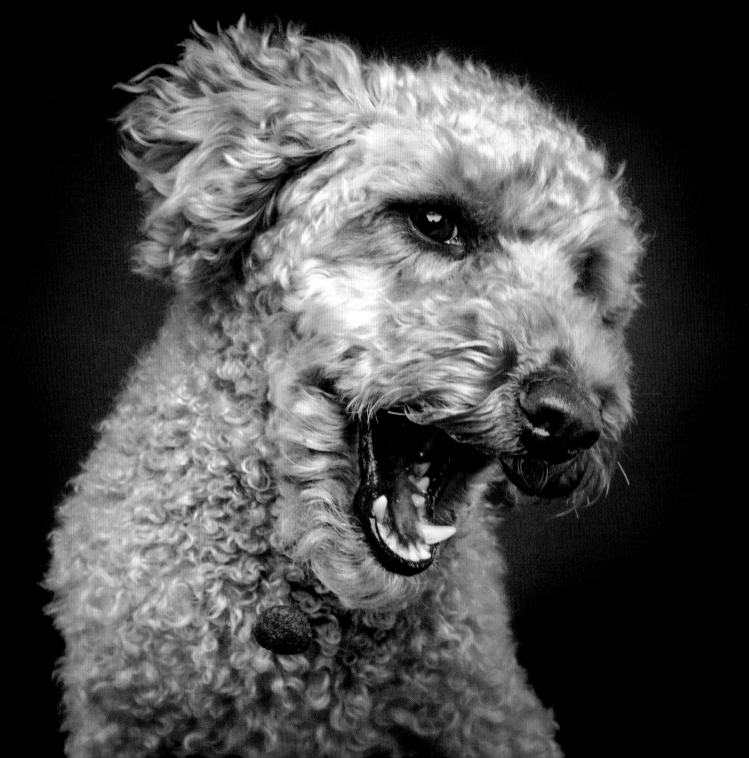

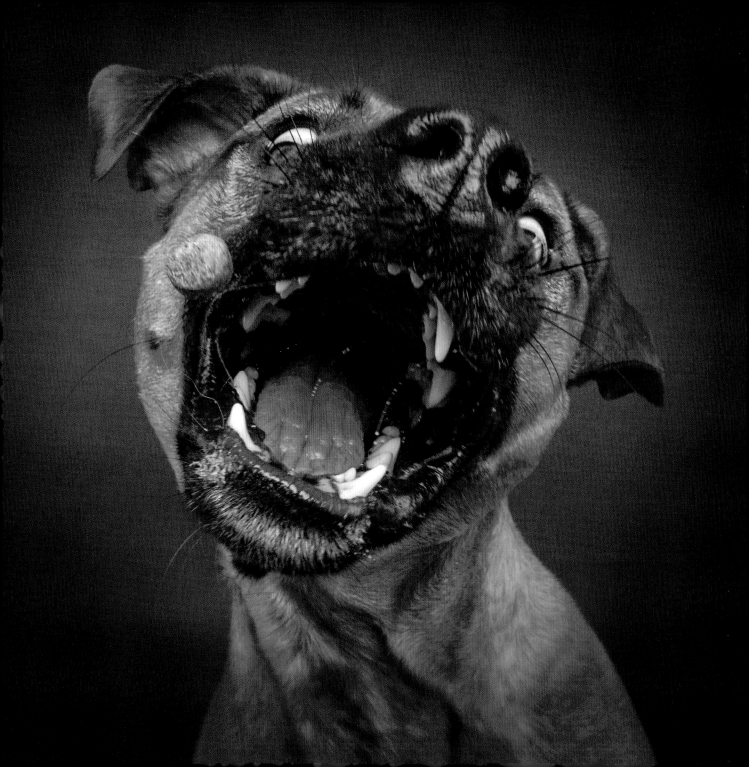

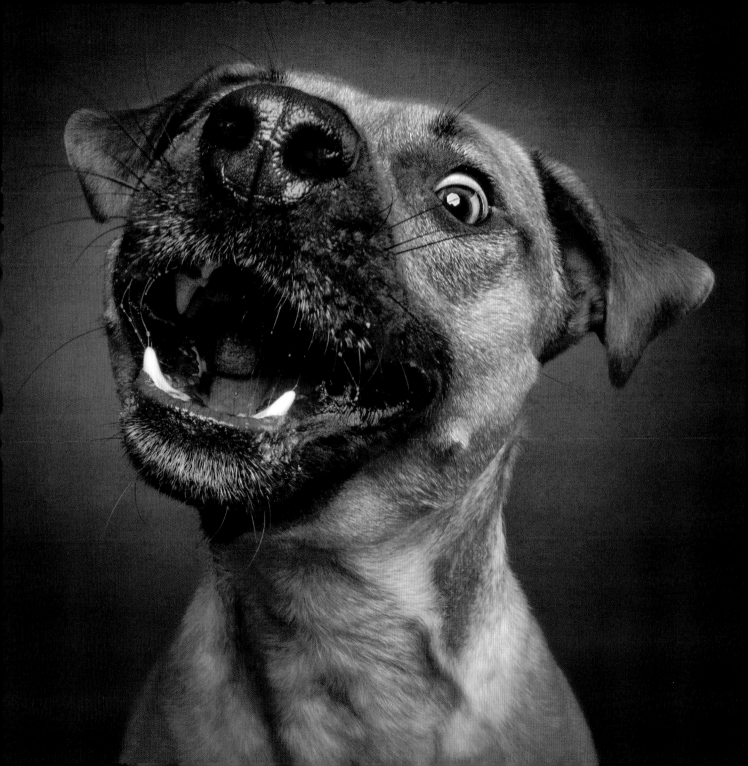

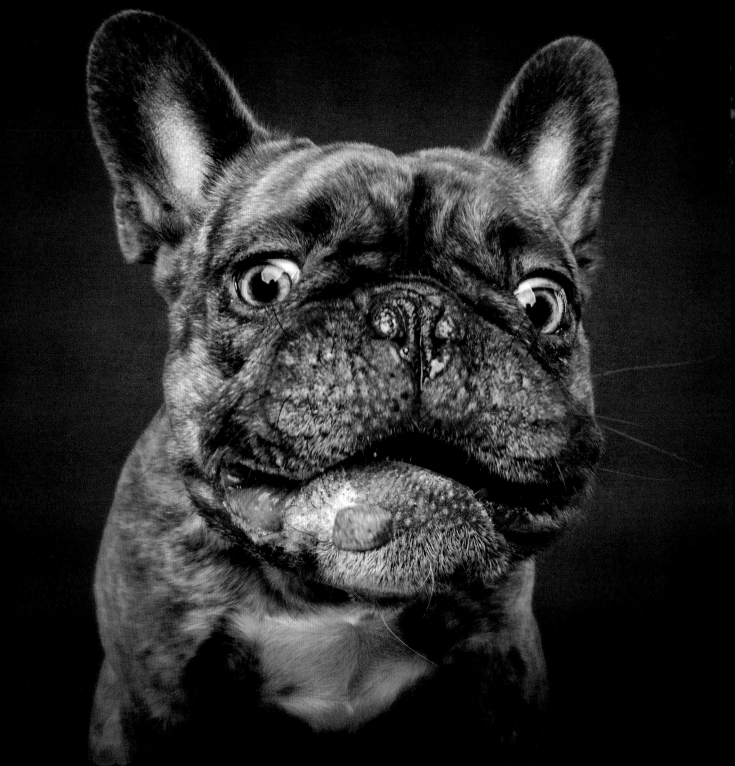

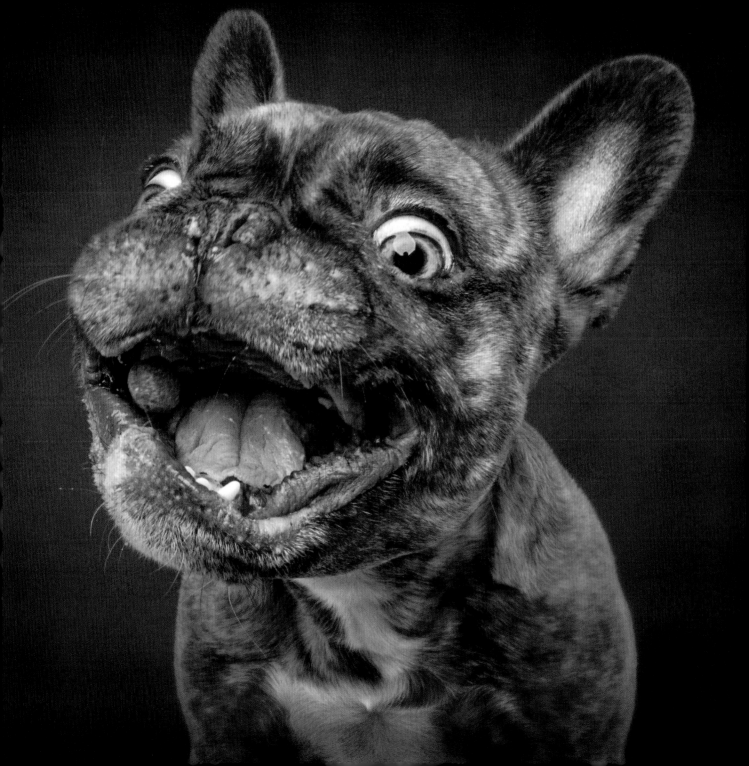

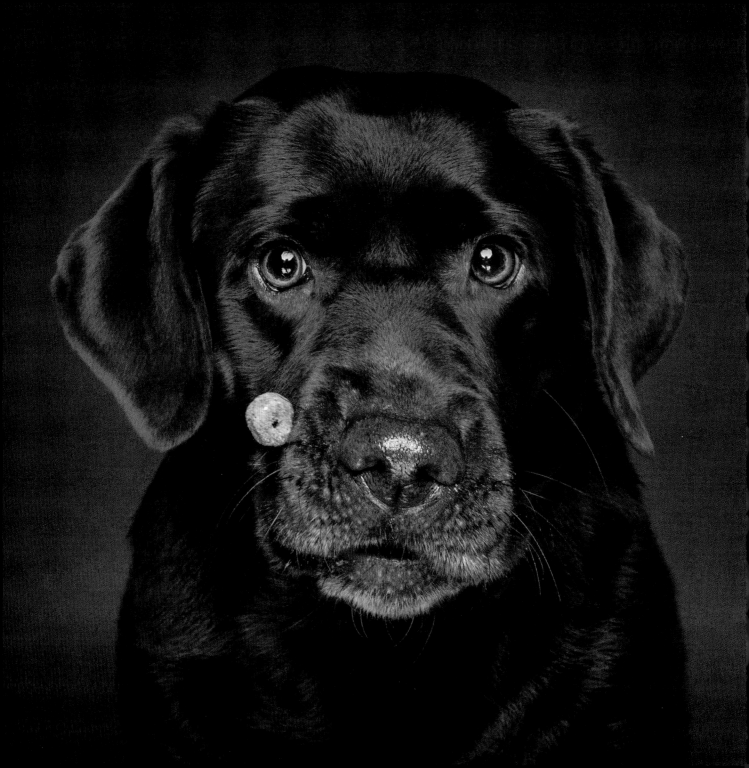

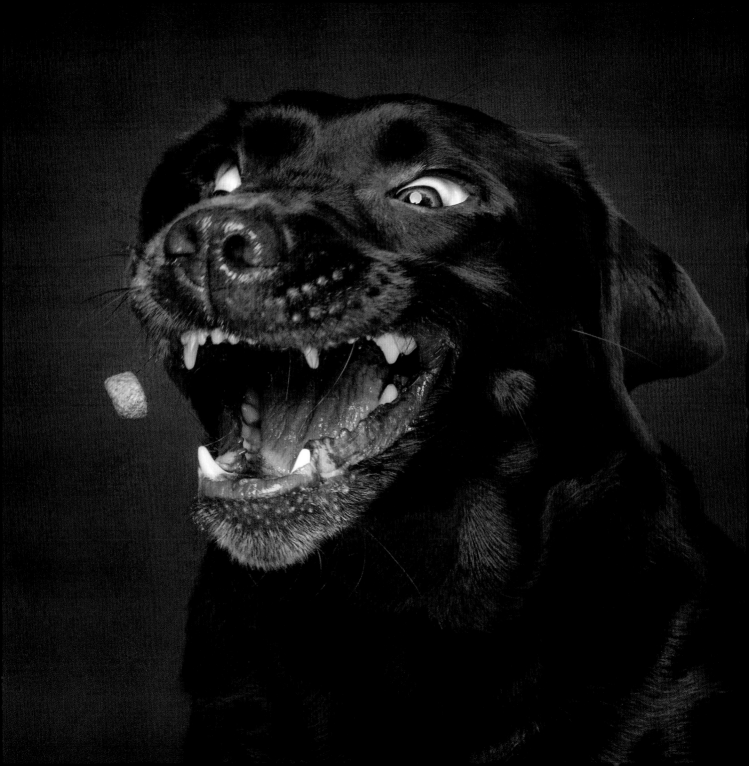

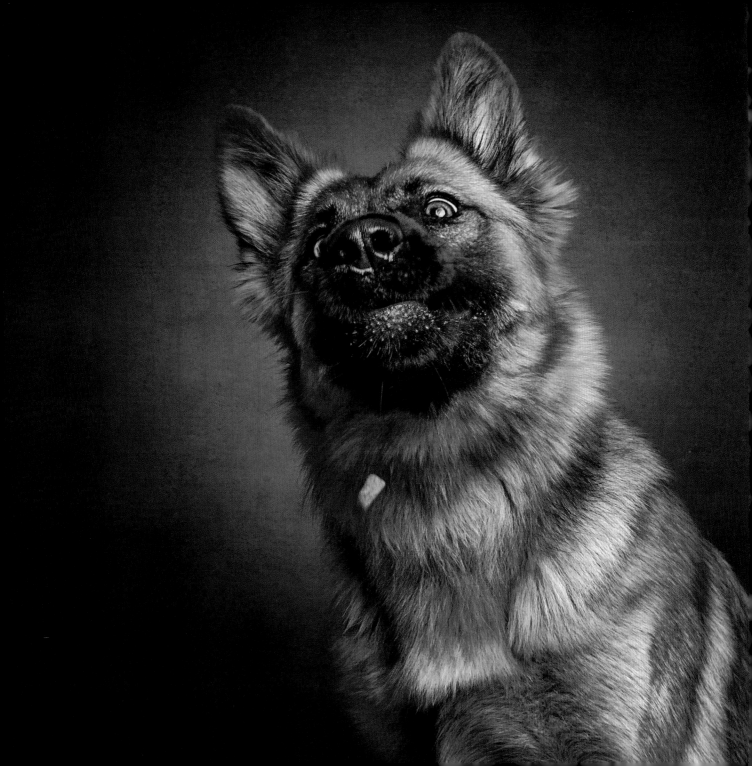

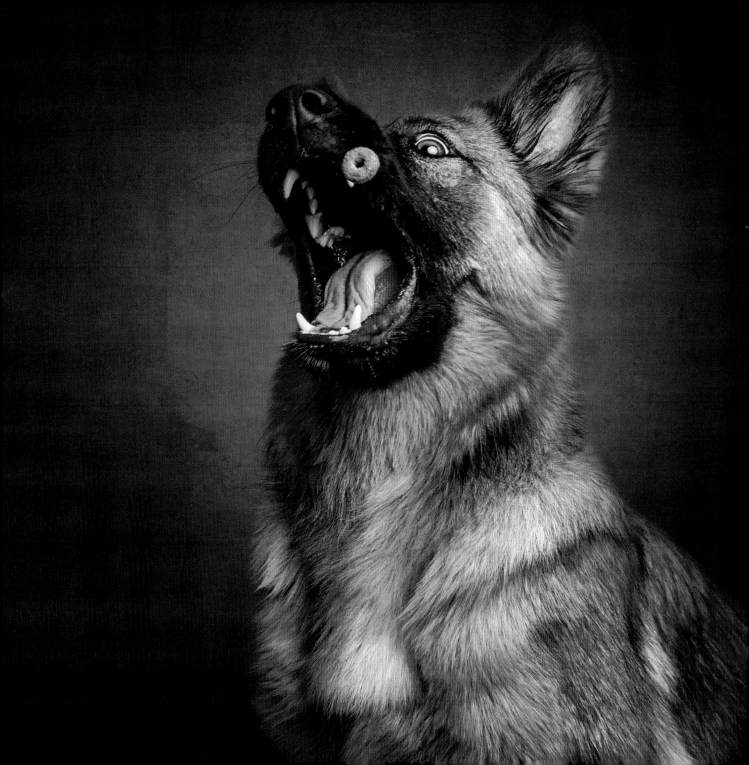

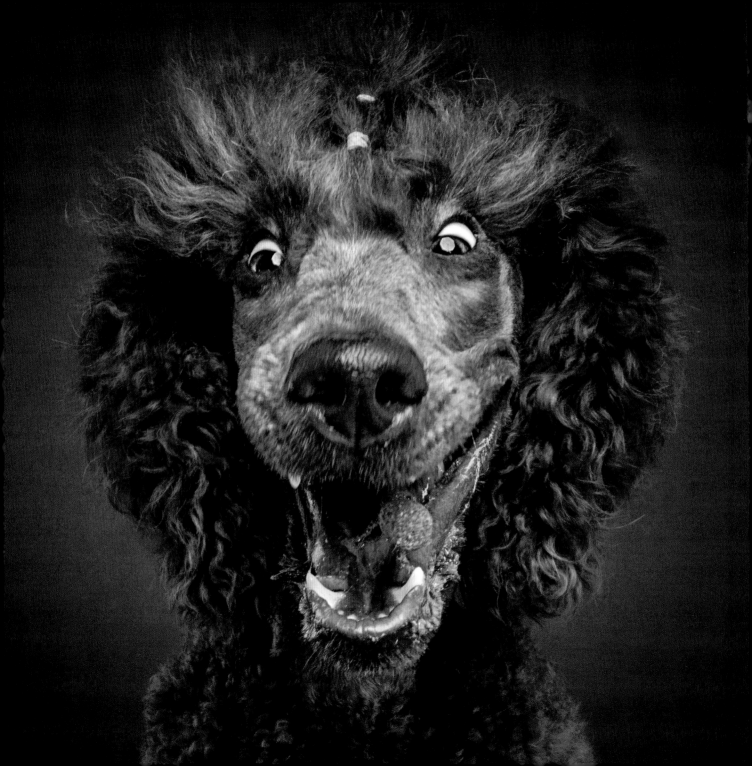

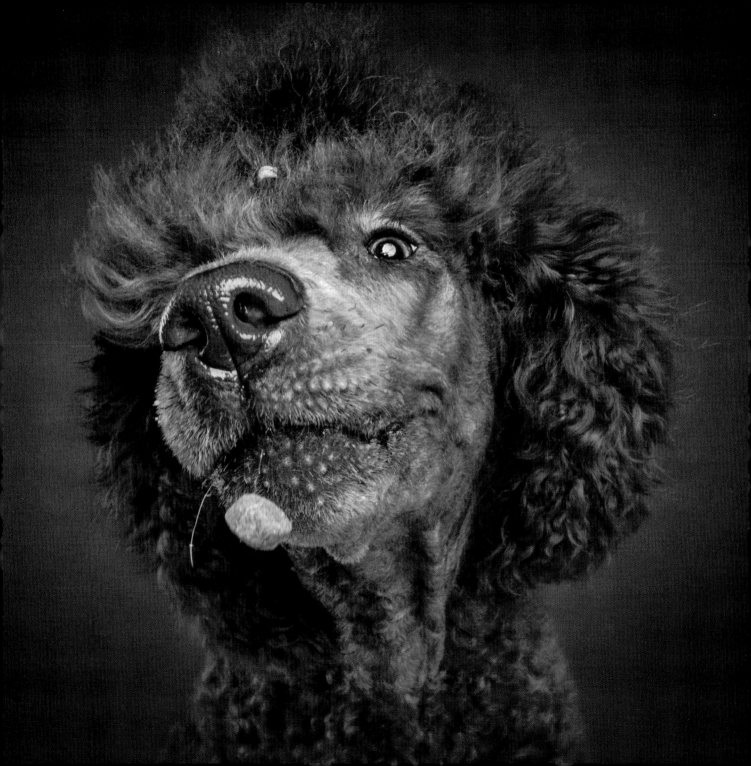

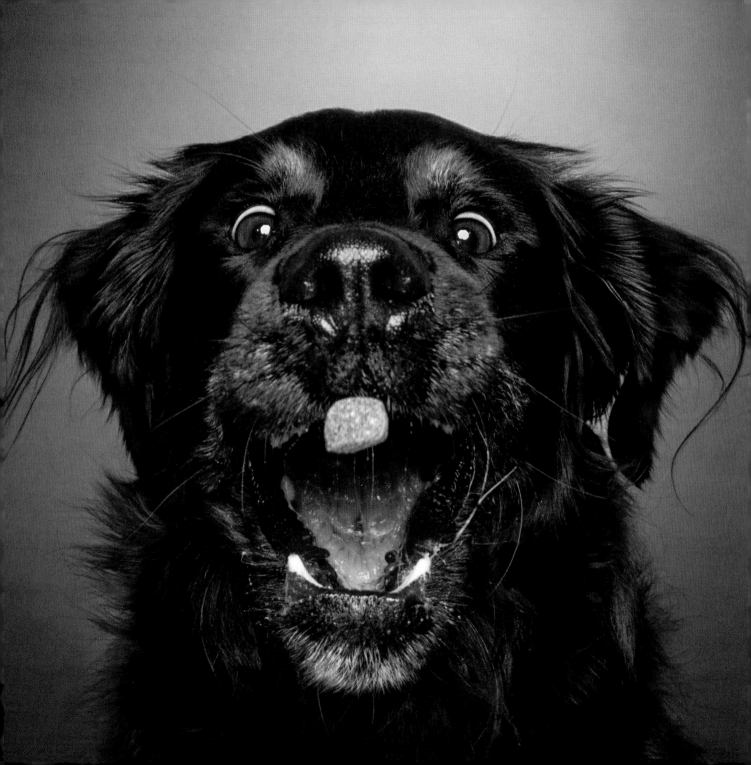

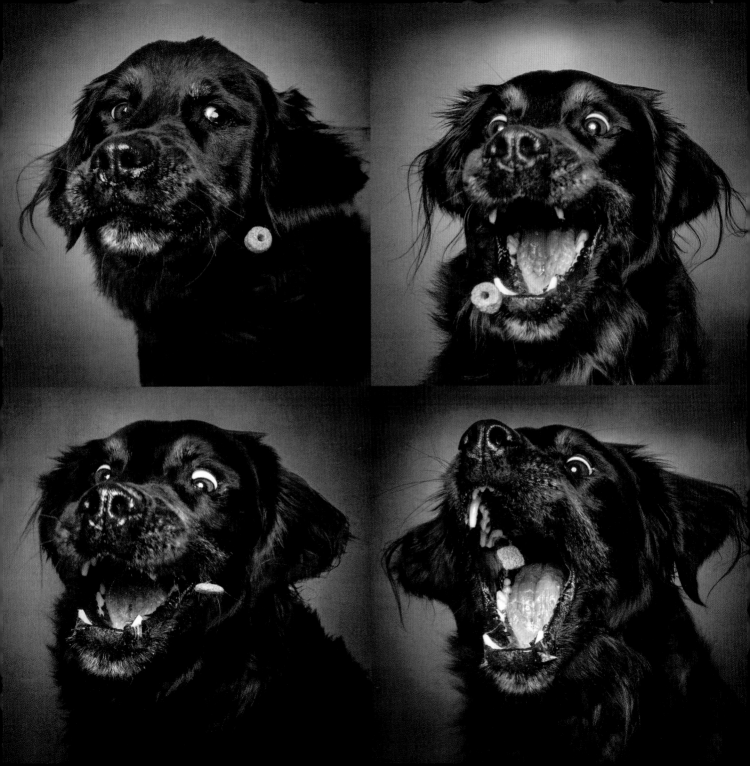

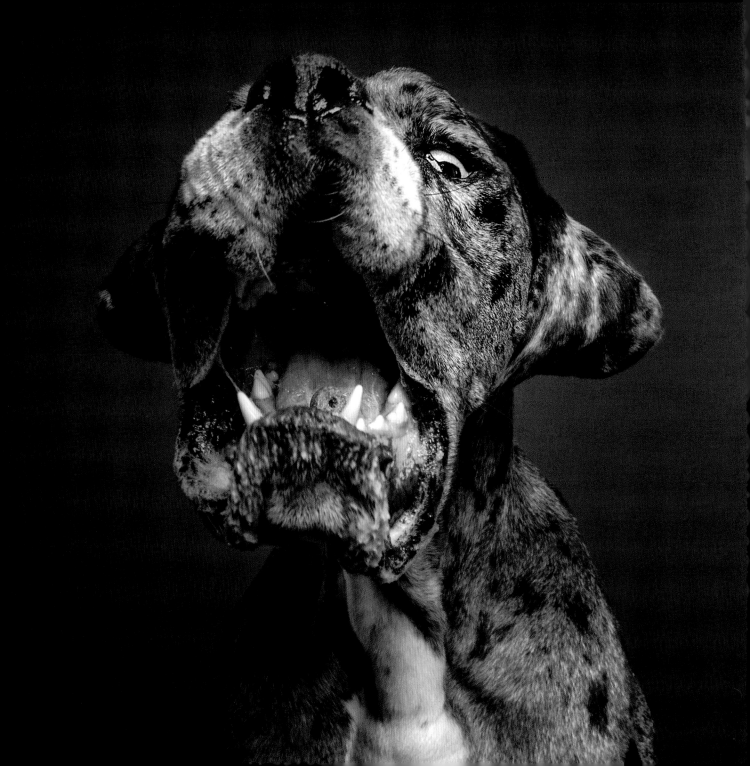

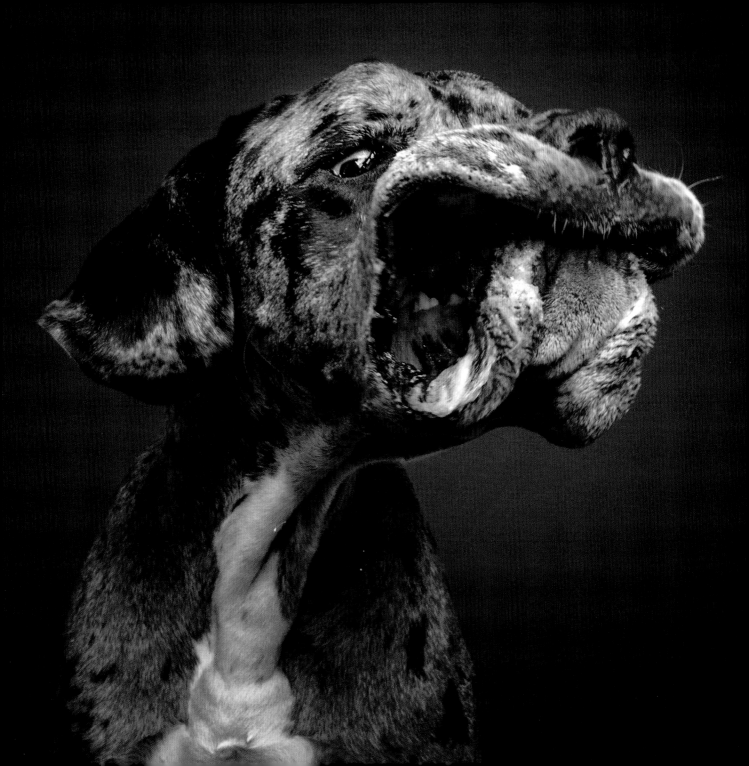

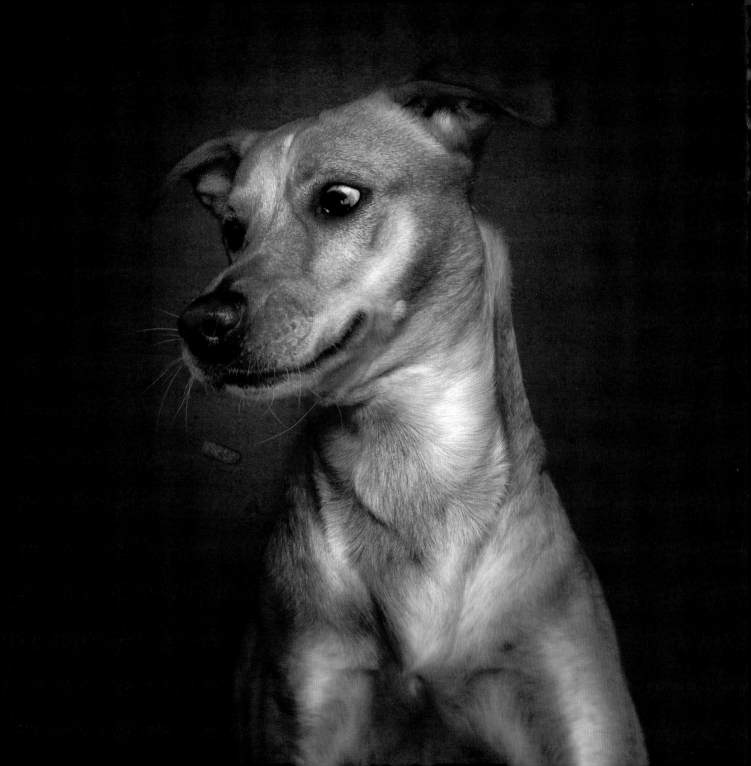

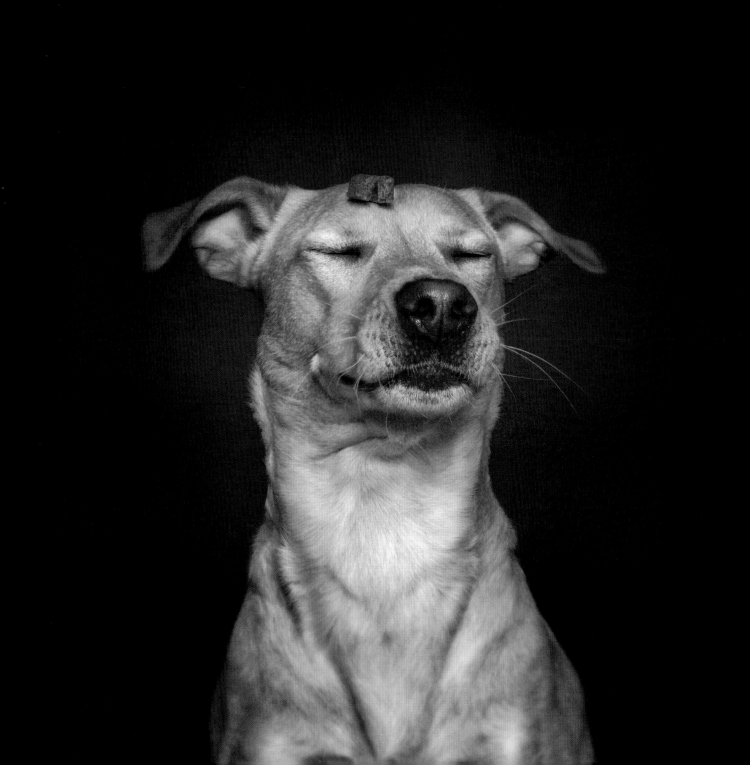

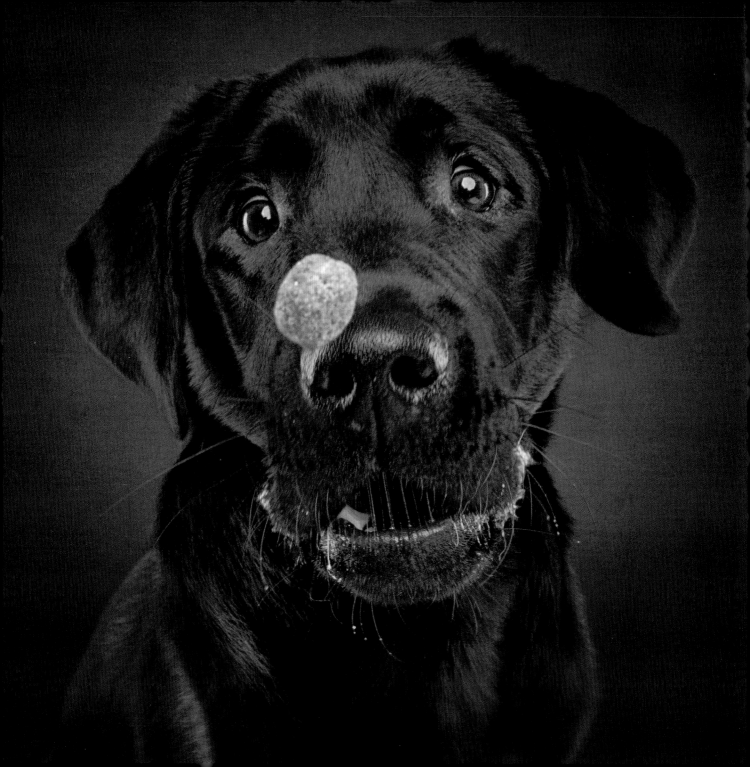

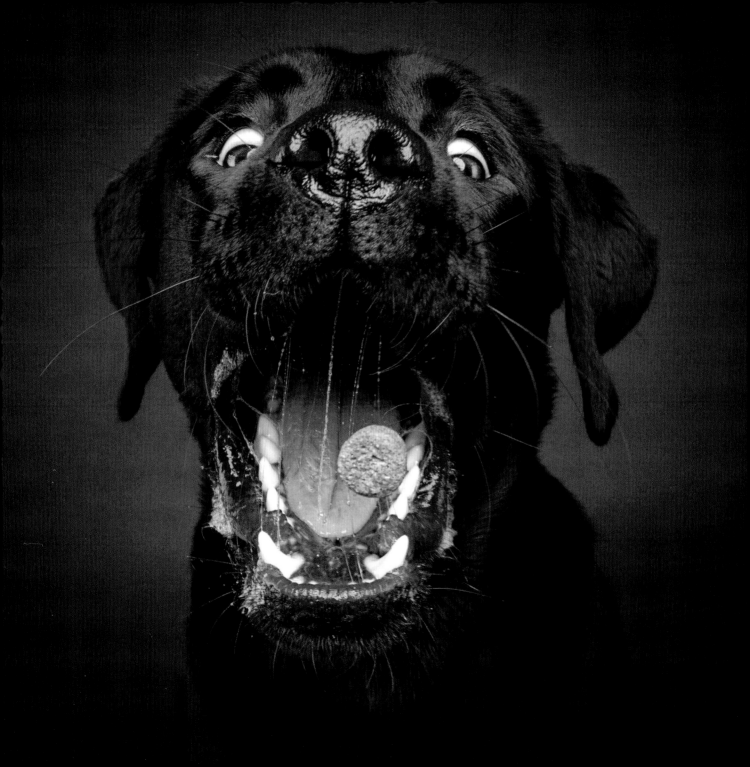

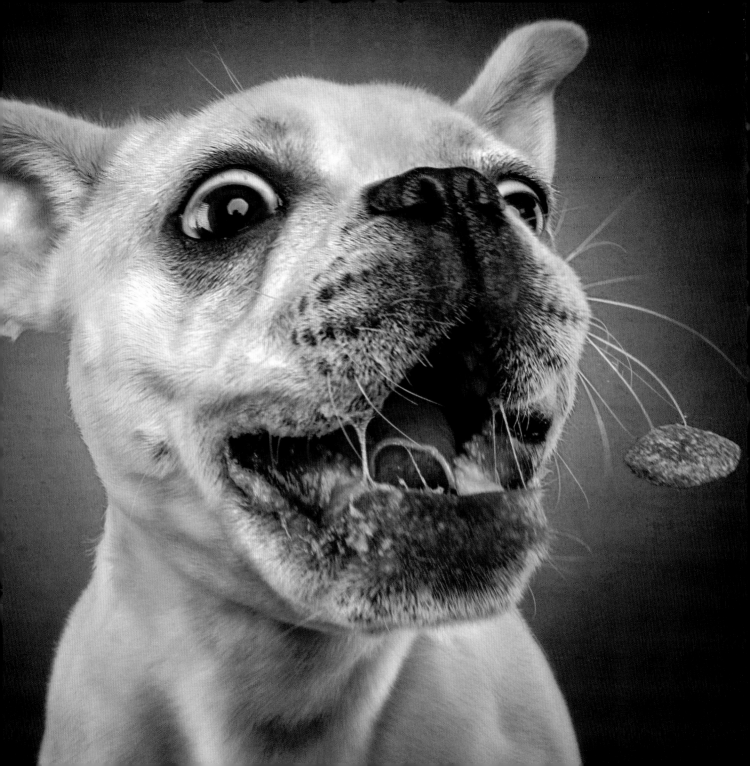

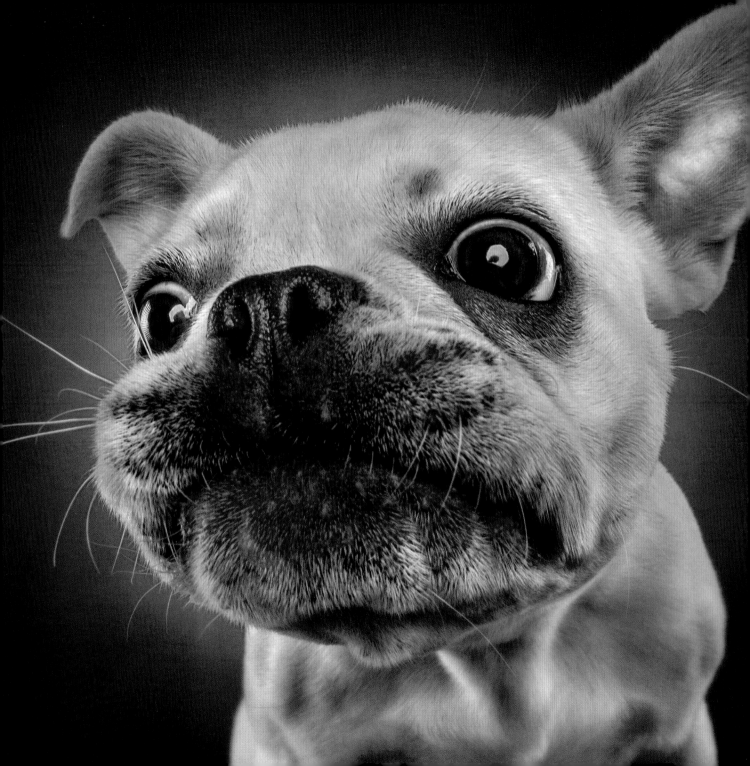

THE DOGS

Many thanks to these amazing models (and their owners) that made this book possible.
Here are the dogs in order of their appearance.

Emma

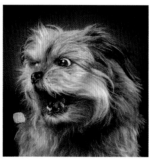

Paddy

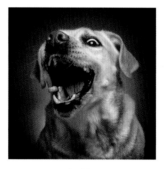

Lotte

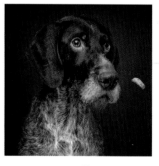

Apollo

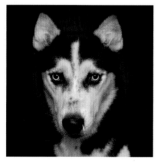

Rex

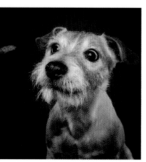

Easy

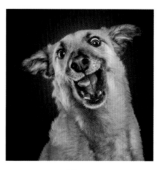

Nico

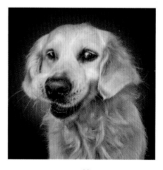

Muffin

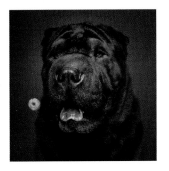
Romi

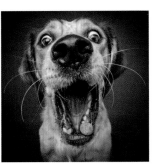
Knut

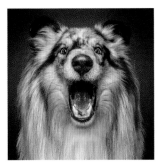
Gene

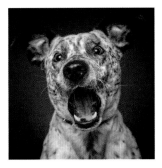
Balou

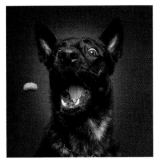
Balko

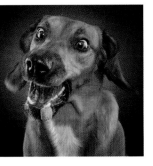
Ammy

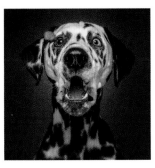
Snoepje

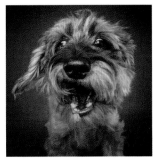
Sam

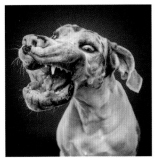
Kimba

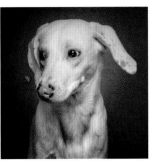
Susy

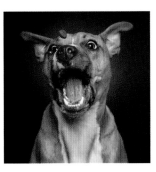
Junior

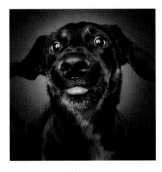
Lucy

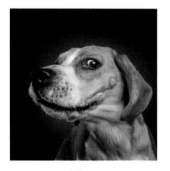

Theo

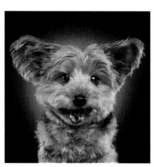

Jorki

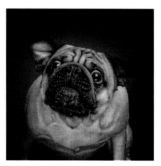

Vincent

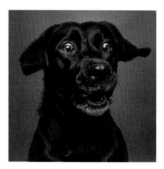

Wilma

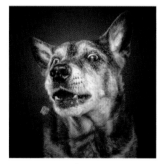

Jakob

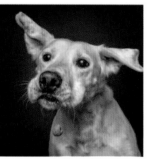

Concha

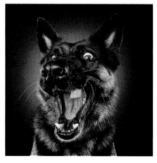

Raya

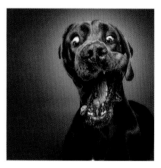

Bobba

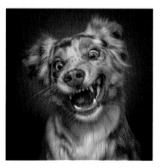

Cody

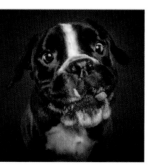

Kalle

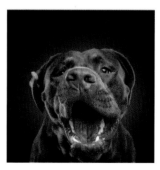

Milow

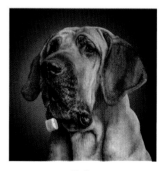

Bubi

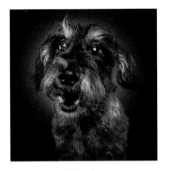

Frieda

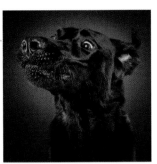

Max

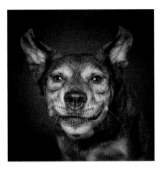

Foxy

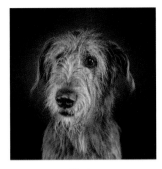

Pixie

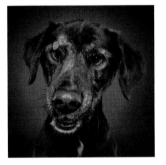

Ben

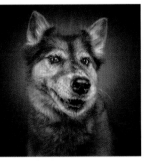

Blue

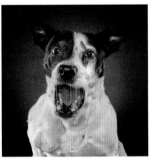

Buffy

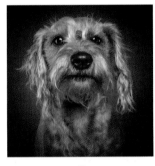

Elli

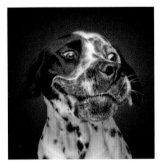

Pepper

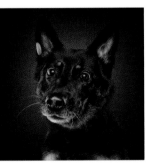

Quira

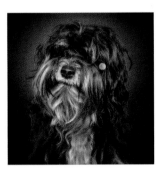

Maila

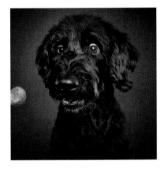

Lucy

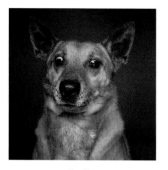

Ricky

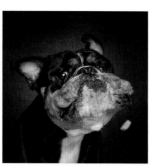

Franky

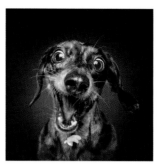

Bella

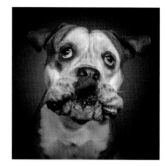

Lotti

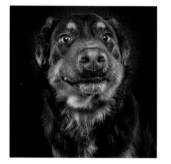

Lou

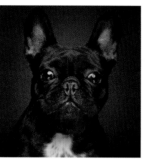

Madox

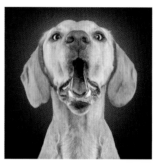

Grappa

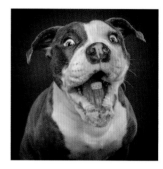

Bumblebee

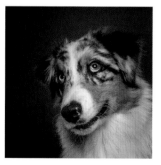

Koda

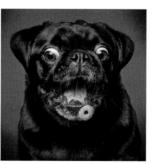

Tanja

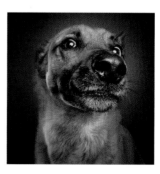

Joe

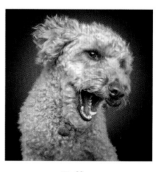

Toffee

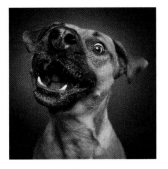

Chico

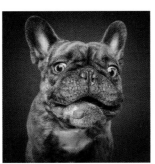

Carlos

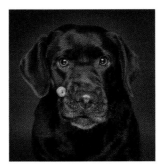

Oonagh

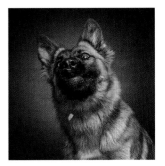

Püppi

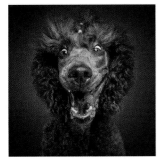

Doris

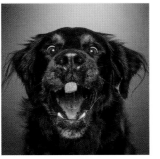

Lotta

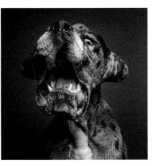

Ghandi

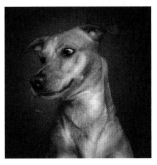

Lisa

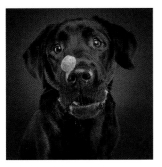

Nero

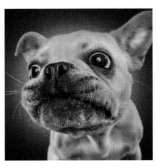

Maja

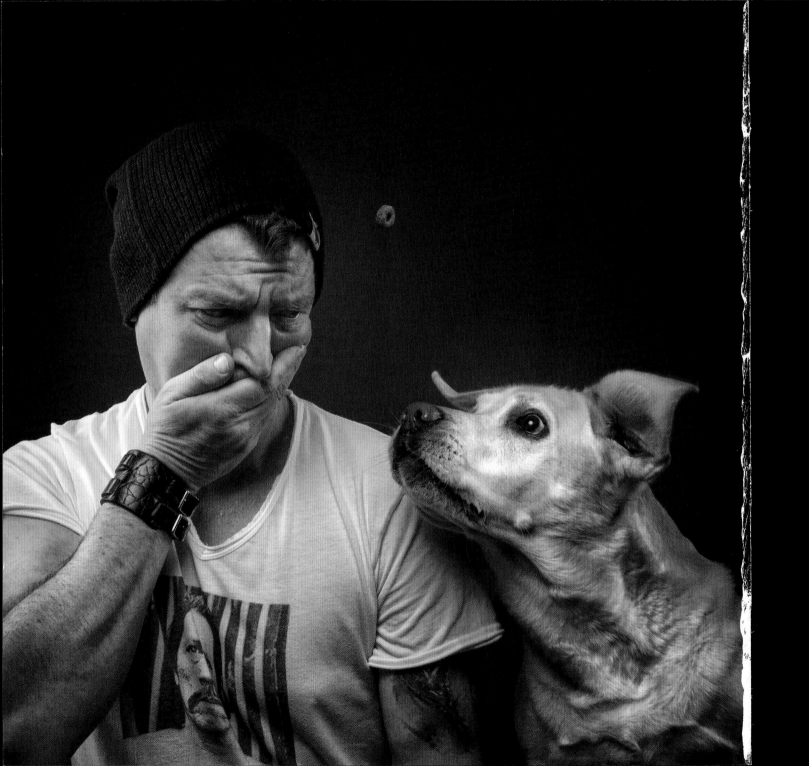